BURNISTON TO RAVENSCAR

THROUGH TIME

Robin Lidster

Including
CLOUGHTON, HAYBURN WYKE
& STAINTONDALE

AMBERLEY PUBLISHING

Acknowledgements

I would like to thank the following people for their help over the years and for allowing me to use their photographs in this book: J. W. Armstrong, Bernard Artley, Alan Brown, R. W. Carr, Mrs M. Carter, Rhoda Cockerill, Frank Dean, Phyl Donson, Peter Grey, Ken Hoole, Mr & Mrs Kirby, Edward Leadley, Emily Milestone, Cecil Ord, Frank Rimington, Val Russell, Ernie Sanderson, Colin Spink, Guy Watson, Dave Williams, and Doreen Williams.

I would also like to record my thanks to the postcard and photograph publishers who have left a valuable historical record of the villages included in this book: Boxell & Co., C. S. Coulson, A. M. Cromack, Hudson, David Pecket, A. M. Pepper, T. H. Spence, H. O. Taylor, T. Taylor & Son, and J. W. F. Tranmer.

I am delighted to thank Arlene and Dennis for bringing the 'Canadian tea party' to Cloughton and, last but by no means least, my thanks as always to my patient wife Val for all her support and encouragement.

Front cover images:
Progress at Stainton Dale Station: Where trains once whisked passengers off to Scarborough or Whitby, and the intermediate villages, cyclists now pedal their way along the scenic 21 mile route between the two towns.

First published 2010

Amberley Publishing
Cirencester Road, Chalford,
Stroud, Gloucestershire, GL6 8PE

www.amberley-books.com

Copyright © Robin Lidster, 2010

The right of Robin Lidster to be identified as the Author of this work has been asserted in accordance with the Copyrights, Designs and Patents Act 1988.

ISBN 978-1-84868-669-4

British Library Cataloguing in Publication Data.
A catalogue record for this book is available from the British Library.

Typeset in 9.5pt on 12pt Celeste.
Typesetting by Amberley Publishing.
Printed in the UK.

Introduction

This book looks at the villages and communities of Burniston, Cloughton, Hayburn Wyke, Staintondale and Ravenscar that are situated on the North Yorkshire coast between Scarborough and Robin Hood's Bay. In my previous book in the *Through Time* series on the Scarborough & Whitby Railway I illustrated all the stations along the route and this book takes the coverage a stage further by looking at the changes in some of the villages along the line. It does include a further selection of photographs of the stations as each one was important to the life and economics of their respective villages in the years before motorised road transport became universally available.

In the villages some types of buildings have been photographed more than others and these include – churches and chapels, pubs and post office, village shop and garage, schools, blacksmiths, mills and the 'last thatched cottage', nearly every village seems to have had one! Events and incidents recorded by the photographers include agricultural shows, foxhounds, village bands, shipwreck and stranded whales and a variety of forms of transport from horse-drawn waggons to charabancs. All of these subjects can be found in this book that I hope will provide a rich visual glimpse into the life of the villages over the past century.

All the villages are close to the coast, with a road that links them all together in a direct line, but they were, from 1885 to 1965, also connected by the Scarborough & Whitby Railway. Before the road over the moors was constructed the original road between Scarborough and Robin Hood's Bay ran through or near the villages, past the old mill at Ravenscar, and on down to the beach at Stoupe Beck. The route continued along the sands to Robin Hood's Bay so it was impassable at or near high tide!

The railway had a great influence on the villages and their development at a time when the country as a whole was still going through its greatest changes – from an agricultural to an industrial

economy, from horse-drawn to mechanical transport, from closed isolated communities to the freedom to travel and work anywhere.

As far as possible the photographs have been arranged in topographical order from the south end of Burniston up to the north side of Ravenscar. There have been many hundreds of photographs published in the past, many in the form of picture postcards, and the collection presented here is largely a personal one as it is impossible in a book of this size to include more than a small selection of the ones that I have found the most interesting in comparison with the present day scene.

Some of the sources of information used in the preparation of this book are listed on the last page and give further details of the rich heritage of this area. Scarborough Library also has a comprehensive collection of material covering the history of this area that is also one of great scenic beauty and variety and, where possible, I have tried to illustrate a few of the attractive and spectacular locations along this coast.

~ CHEVIN ~
J · R · LIDSTER

Burniston Gardens
This was the last house built down Burniston Gardens in the 1930s and was home to the author as a small boy. More recently a new estate has been built in the fields beyond the house where cows once used to roam.

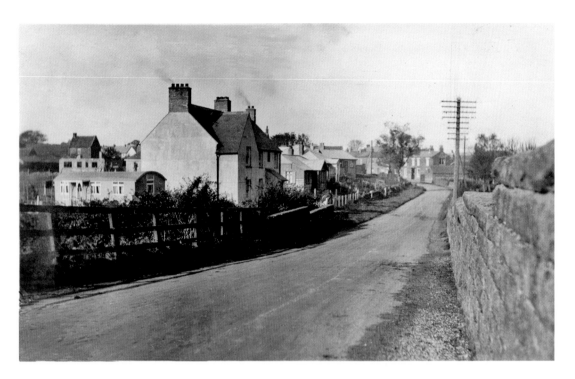

Approaching Burniston on the Coastal Road
The view along the Coastal Road towards Burniston from Willimath Bridge in about 1929. The Blacksmith's Arms (now called The Oak Wheel) can be seen in the far distance. On the left the old 'summer house' has been replaced by a modern bungalow and the white house has been extended at the far end.

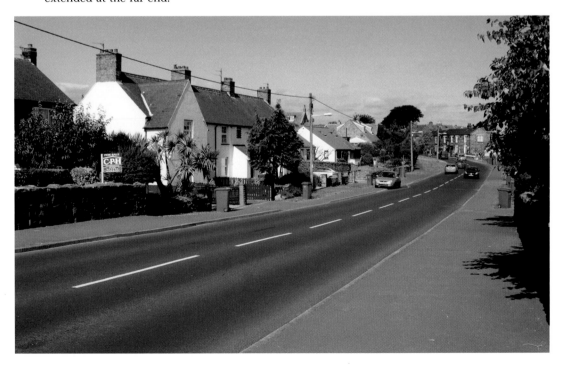

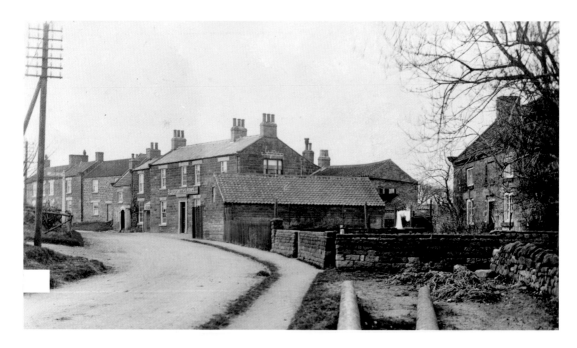

The Blacksmith's Arms Changes to...

The Blacksmith's Arms and adjacent outbuildings in about 1913. On the left South End road joins the Coastal Road into Burniston. The Blacksmith's Arms was the regular meeting place of the Burniston Friendly Society, established in 1857 to help the poor and needy members of the community. In 1829 the population was 345 but by 1890 it was down to only 238 but this may partly be accounted for by boundary changes.

Compare these two photographs with the matching pair on the opposite page.

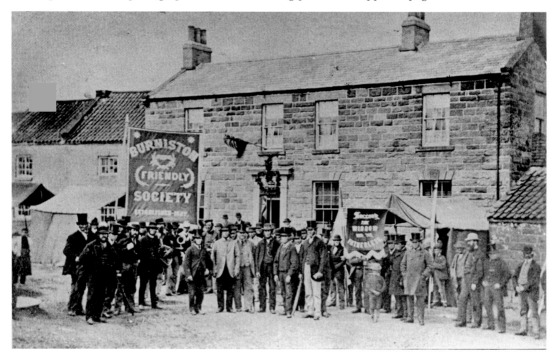

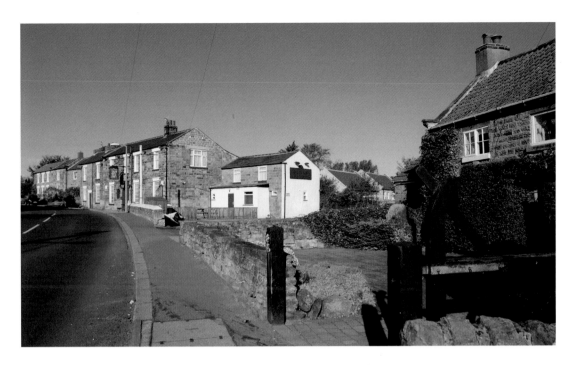

...the Oak Wheel

The Oak Wheel, as the Blacksmith's Arms is now called, has an extension and car park that covers the area once occupied by the outbuildings seen on the previous page. A Thomas Petty was recorded as the victualler at the Blacksmith's Arms in 1890. At various times in the past the name of the village has been spelt as Brinniston, Brinnistun, Briningeston and Briningston.

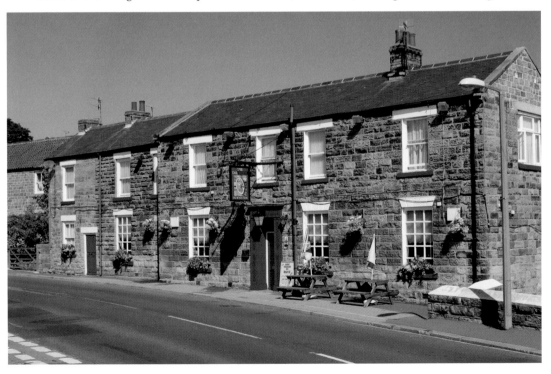

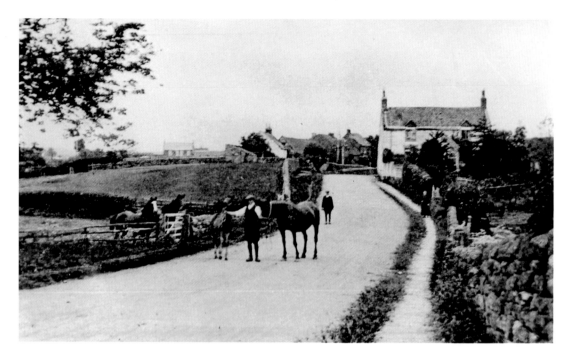

Approaching Burniston on the Old Scalby Road

The main road from Scarborough (now the A171) used to approach Burniston through South End past Emmerson's Farm, on the right. A short by-pass was built in the 1920s, the position of which is indicated by the speed camera sign. Part of the original road still remains as a short cul-de-sac alongside the new road. New houses were built in the 1930s alongside the new road, towards Scalby, and the beginnings of a small estate created at Burniston Gardens (see page 4).

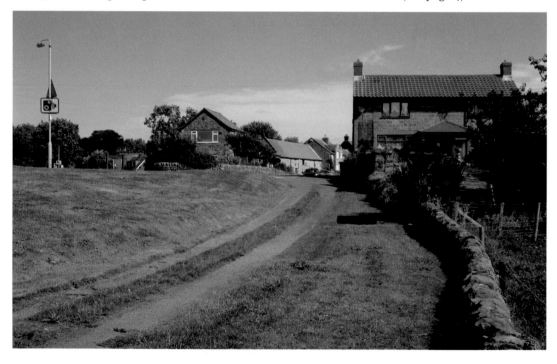

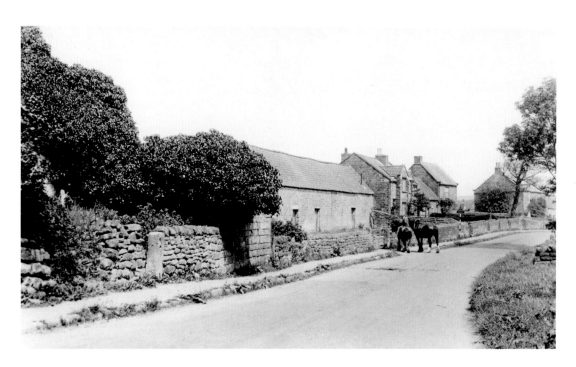

South End, Burniston

South End in the 1930s after the by-pass was built and all the Scarborough-Whitby traffic was diverted. The road became a quiet backwater until barns were converted and new cottages and bungalows built on the south side. It is recorded that Burniston's last thatched cottage, originally situated behind the trees on the left in the old photograph, survived until the 1920s. The building on the far right was South End House, built for William Hodgson in 1820.

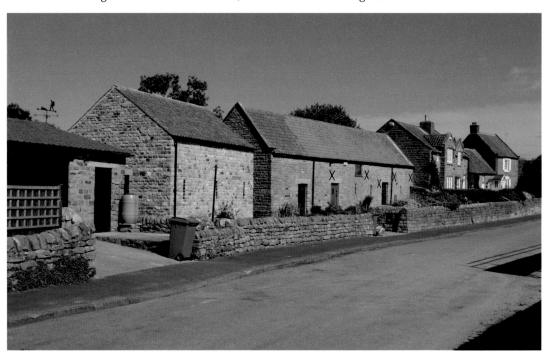

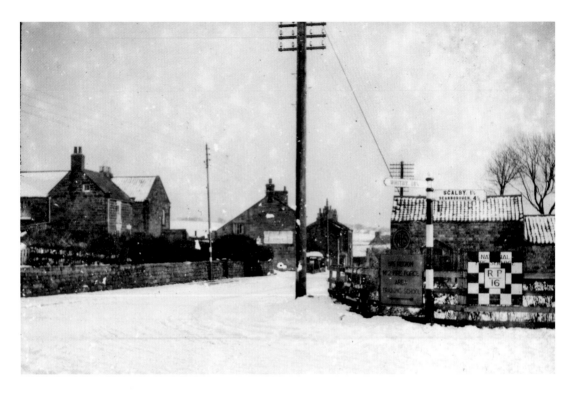

The Coastal Road/Scalby Road Junction

On the right the main road from Scarborough to Whitby forms a junction with the Coastal Road to Scarborough, in the centre. Down the Coastal Road the Blacksmith's Arms (Oak Wheel) can be seen in the far distance. On the right a sign indicates the location of the *National Fire Service Reporting Post 16* at the junction that has now been replaced by a roundabout. The outhouses or barns on the right have been replaced by a modern bungalow that is screened by the hedge.

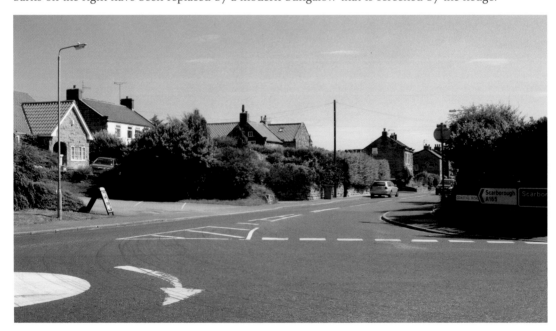

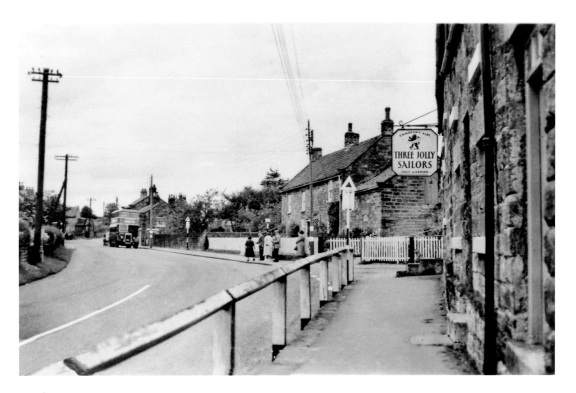

Three Jolly Sailors on High Street

The view from the entrance to the Three Jolly Sailors looking up the High Street in about 1932. This pub was formerly known as the Ship Inn, as far back as 1829, and traces of a church were found in Chapel Garth behind the Inn. Burniston was once a parish in its own right but came within the ecclesiastical parish of Cloughton in 1874. Just beyond the entrance to the Three Jolly Sailors is the start of Rocks Lane that leads down to Burniston Bay.

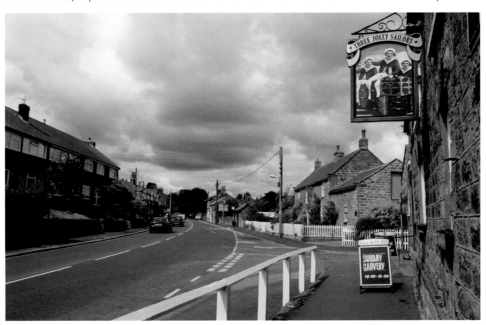

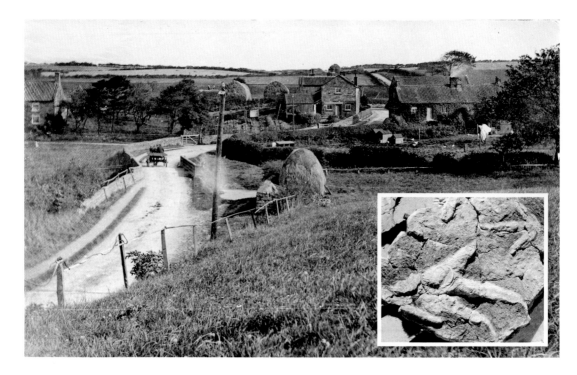

Making Tracks down Rocks Lane

Down Rocks Lane, on the way to the beach, the road crosses Prickybeck Bridge and, beyond the buildings, passes under the old railway bridge. The line can be seen to the left of the buildings, in the centre of the old photograph, passing behind the tops of the two haystacks. A new estate of houses has been built in the field on the right accessed by the new road – Rocks Lane Close. On the beach footprints of dinosaurs can be found in the Middle Jurassic sandstones.

Inset: fossil dinosaur footprints from Burniston Bay.

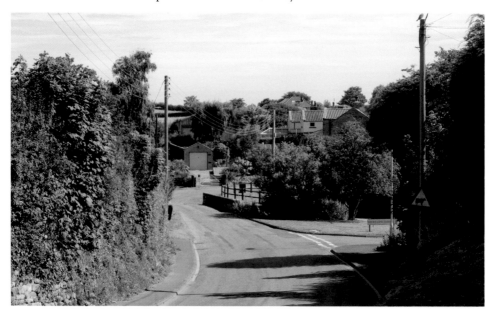

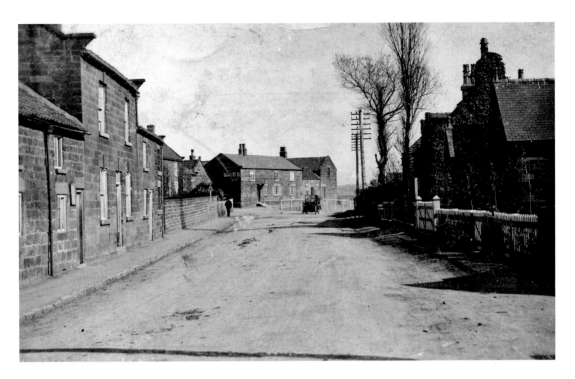

High Street and the Old Baptist Chapel

In the distance the Three Jolly Sailors is passed by a single motor car in about 1930. On the right is the old Baptist Chapel demolished in the 1980s (see next page). To the right of the telegraph posts in the old photograph is The Haven, once the home of H. W. Head who ran the world's first butterfly farm in the extensive gardens behind the cottage. He had originally started his business at Scarborough in 1884.

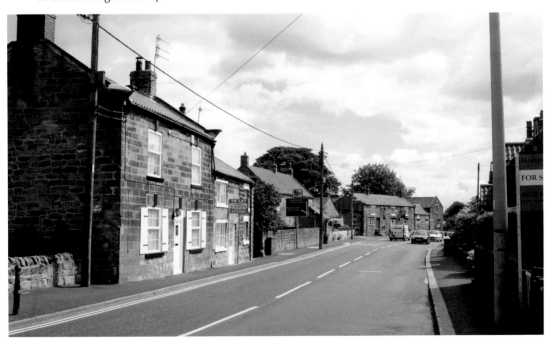

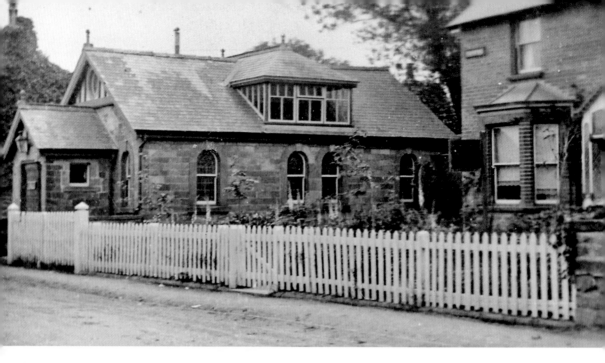

The Baptist Chapel

In 1890 the Baptist Chapel was recorded as being a small stone building with round-headed windows that was served from Scarborough. Harvest Festivals were often held here when a good display of local produce was on display on Sunday followed by its auction in aid of chapel funds on Monday evening. The local lads used to sit on the front seats and buy the apples and pears. Since the chapel was demolished the only things for sale here now are chainsaw carved toadstools!

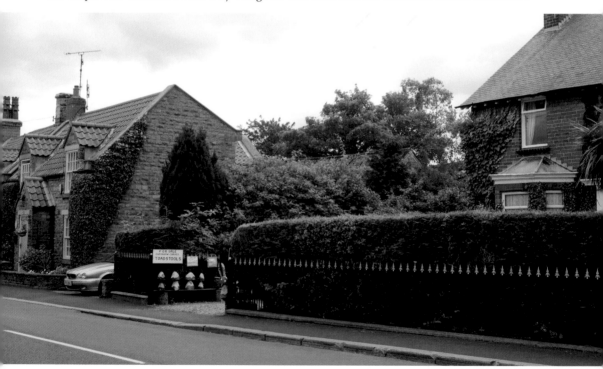

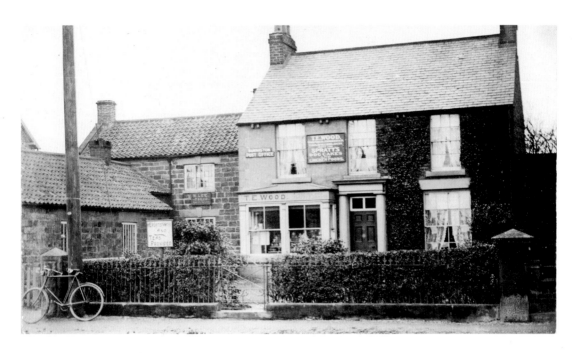

Shopping and Changing

Burniston Post Office, photographed in about 1910, was run in this building by T. E. Wood who also provided "Aerated Waters and Teas". Next door W. Lee was the village tailor. By 1938 J. E. Fletcher had taken over the business that was now run in a new extension spilling out on to the opened-up forecourt with a trestle table of goods and a cigarette machine. The house had acquired a new porch with the name 'Ivy Lodge' above the door. Compare with the photograph on the next page.

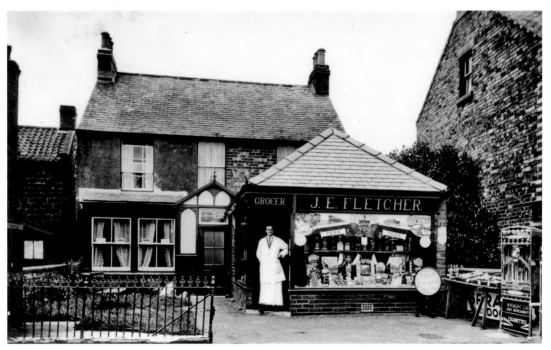

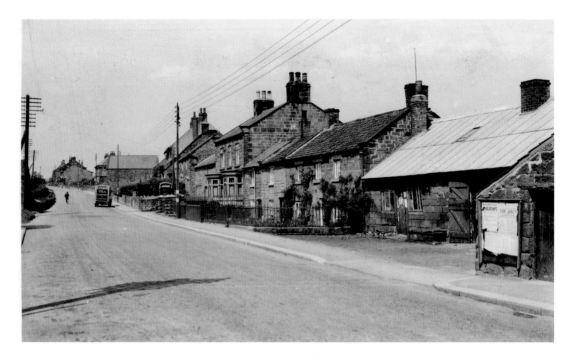

Full Circle for the Post Office

The Post Office moved to a cottage, on High Street, near the telephone box in the old photograph and was run by well known local character Emily Milestone who ran it until 1981 having taken over the business from her aunt, Mary Milestone. The Post Office has now gone full circle as it is back at the former premises of T. E. Wood (previous page). The last vestige of a front garden has disappeared and a letter box and a wheely bin have replaced the old cigarette machine.

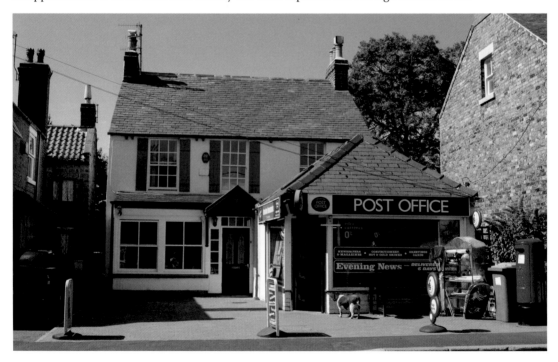

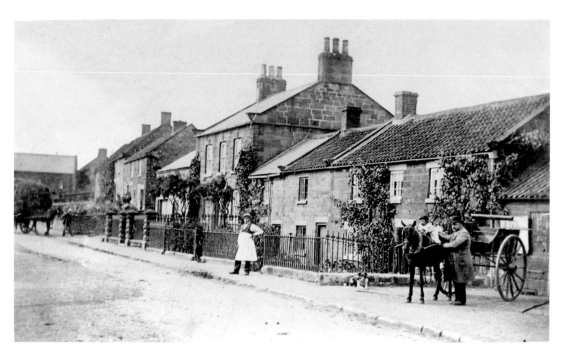

Forging Changes on High Street

Behind the pony and trap is the north end of the blacksmith's forge that can be seen on the opposite page sporting a brand new corrugated iron roof. Every village had its blacksmith, before the advent of the motor car, and Allinson Sedman held that job in Burniston in 1890. The cottages north of the old forge have undergone considerable changes and improvements in recent years with the addition of dormer windows and front porches.

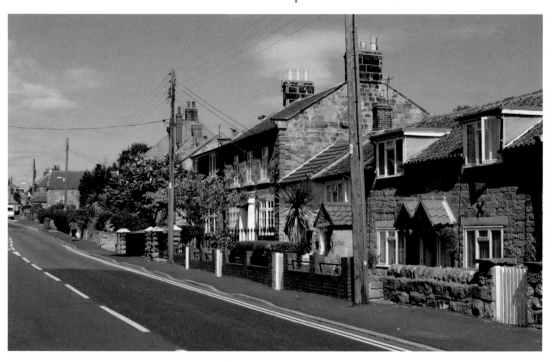

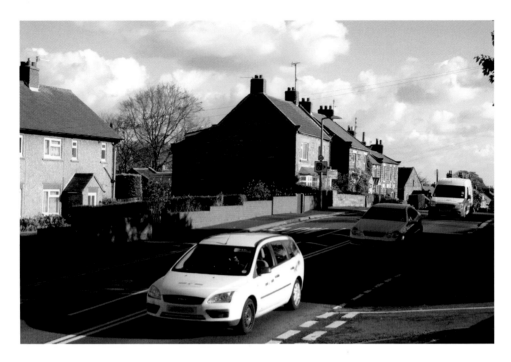

A Change of Pace on High Street

The council houses on the left replaced an earlier building seen in the photograph on the opposite page. In the days of horse-drawn traffic the top of High Street was once a place where children could safely pose for a photograph. On the left, Prospect House was occupied by William Lee, tailor (see page 15) who moved here to run his business in the adjacent hut that had been carried up the village on poles from its position near the old Post Office.

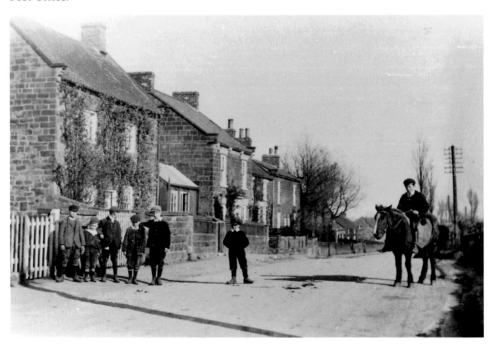

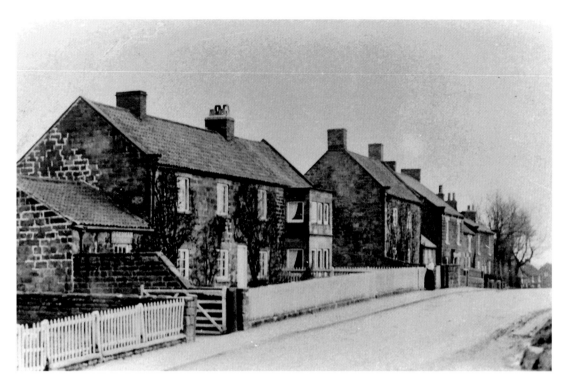

Burniston Ruins

The building on the left was wrecked by a bomb that fell in the front garden on the night of 25 June 1940. Part of the building, with its distinctive chimneypots seen in both photographs, was left standing but the whole block was demolished and replaced with the row of council houses seen on the opposite page. On the same night four other buildings in Burniston were also badly damaged by bombs and were demolished. The following day coach loads of sightseers came from Scarborough to see 'Burniston Ruins'.

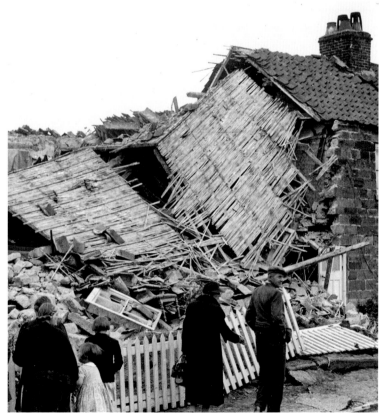

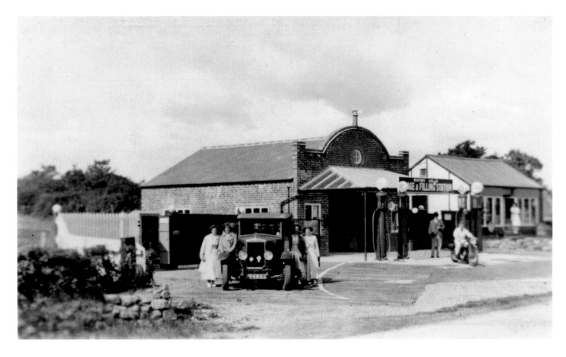

From Whitby Road Garage to...

Whitby Road Garage and Filling Station opened on 10 May 1934, the adjacent shop in 1933. The hand-operated pumps were manufactured by Wayne in 1924/5. Each pump had a different brand of fuel – Shell, BP, National Benzole and Ethyl. One of the tall pumps was sold at an auction on the premises in 1983 and was to be restored. The recently renovated and updated garage largely obscures the art deco façade of the original building.

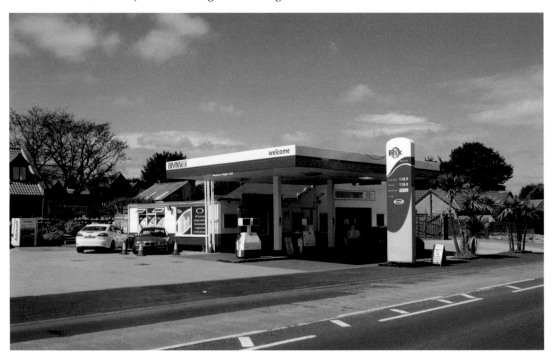

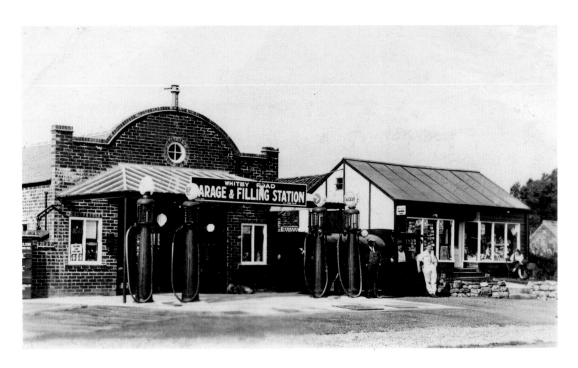

...Burniston Motor Works

Largely hidden behind the pumps on the right, in the old photograph, is a National Benzole delivery tanker that is minute in comparison to present-day models. The old façade of the original garage stands in the shade of the new forecourt canopy and the row of pumps has been replaced by a row of palm trees. The shop, selling a variety of goods including picture postcards, has long since disappeared.

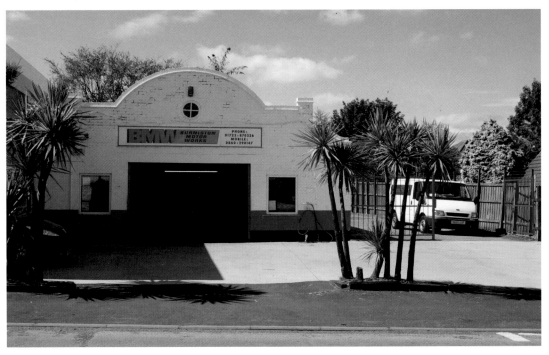

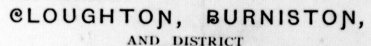

CLOUGHTON, BURNISTON,
AND DISTRICT
FLORAL & HORTICULTURAL SOCIETY

THE ELEVENTH ANNUAL

❖ EXHIBITION ❖

OF

Plants, Flowers, Fruits, Vegetables, and Farm Produce,

Will be held in the SCHOOLROOM, CLOUGHTON,

On TUESDAY, AUGUST 23rd, 1887.

Shows and Exhibitions

Shows and exhibitions have a tradition going back many years as can be seen from the announcement for the eleventh annual exhibition of the Cloughton, Burniston and District Floral & Horticultural Society held in 1887. Burniston Show also has a long history and has been held in various fields around the village over the years. The lower picture was taken in a field behind the Whitby Road Garage in the 1940s. The back of the garage can be seen in the top centre of the photograph.

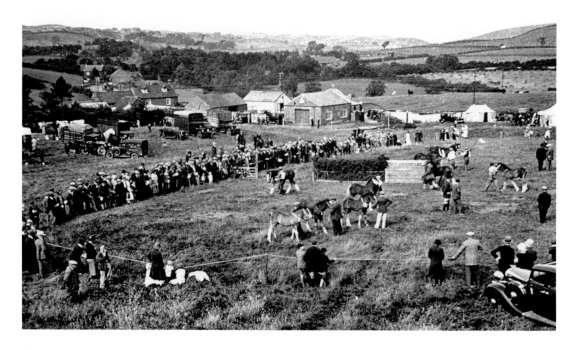

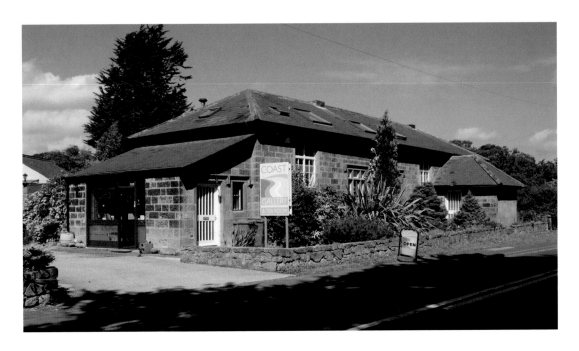

School's Out!

The school at Burniston stood beside Mill Lane on the way to Cloughton. It had not been used for many years, being replaced by the much larger and more modern Lindhead School a short distance away, and was recently converted into a smart gallery and tea room. The obligatory school photograph was probably taken around 1900 and shows the schoolmistress in a very smart, but severe, wasp-waisted outfit. The bowler-hatted gentlemen look no match for the teacher!

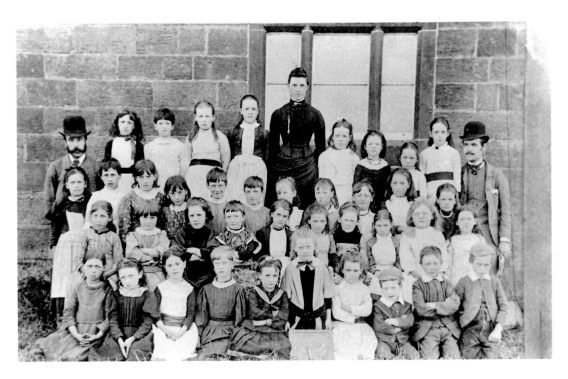

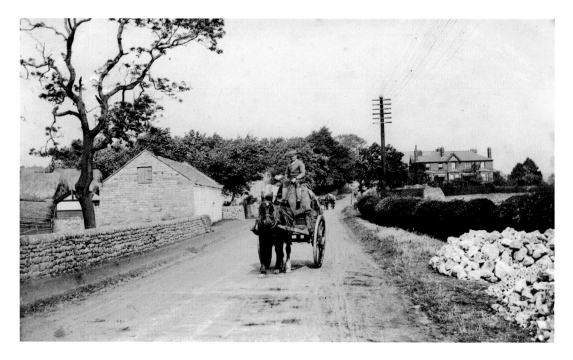

Changing Horsepower on Mill Lane, Cloughton

Where the horse and cart once reined (!) supreme and goods in bulk travelled by train; tankers, wagons and trucks now thunder along this once peaceful country road. The end of the barn on the left can just be seen in the present-day view, to the left of the tree, where it has been converted into a residential property. On the right, hidden behind the trees, houses and bungalows have been built since the old photograph was taken in about 1908.

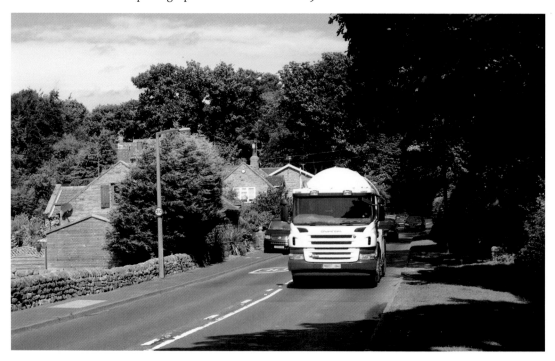

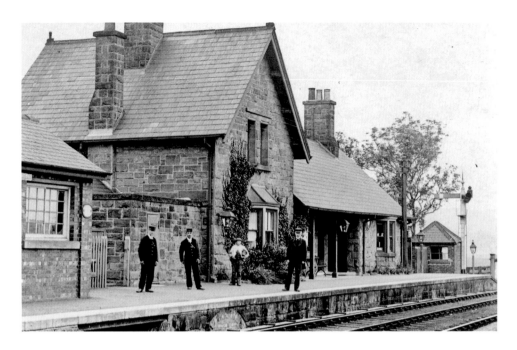

From Timetables to Tea-tables at Cloughton Station

Cloughton station was completed in 1885 just before the Scarborough & Whitby Railway opened in July of that year. The staff were photographed in about 1910 when the stationmaster was McKenzie Proctor. The two-storey section was the stationmaster's house; the single storey contained the waiting rooms and ticket office. On the left the signal box has been replaced by an extension to accommodate holidaymakers. The station also has a popular tea room that, in fine weather, overflows onto the platform and into the picturesque landscaped gardens.

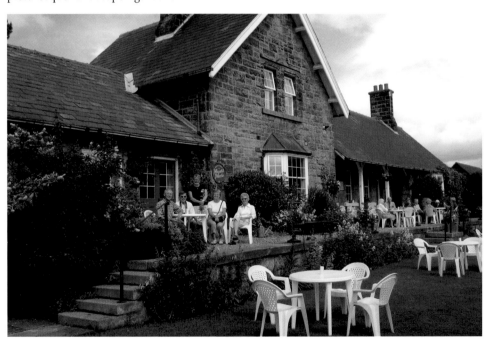

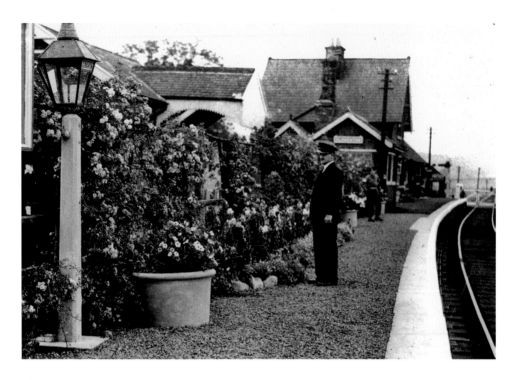

Cloughton: a Best Kept Station

Alf Hart, the last stationmaster at Cloughton, and his staff put up the rustic fencing and planted the climbing roses in 1958. The station won first class prizes in the Best Kept Station competition every year from 1947 to about 1959, except in 1950 when he was disappointed to only take a second class prize! Over 2,000 plants were used in the flower borders, tubs and hanging baskets, all grown from seed at the station. The old goods warehouse, on the left, has recently been converted into self-catering accommodation.

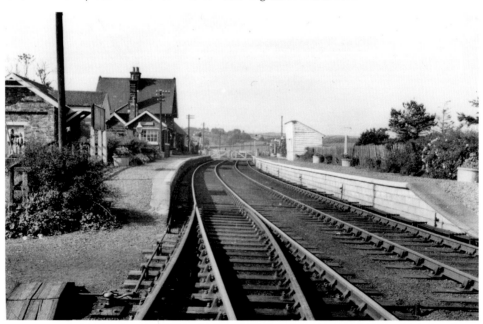

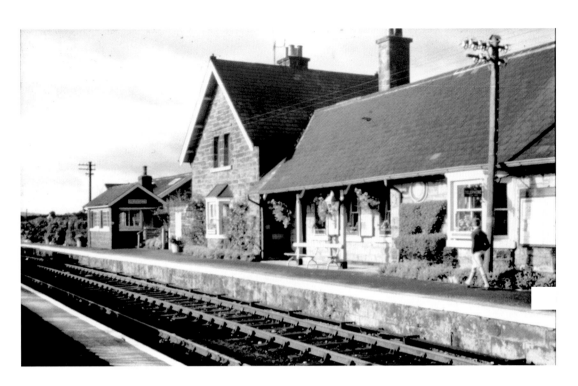

Cloughton Station: Weeding between the Lines?

The station bloomed right up to closure in 1965 as seen in this photograph, taken from a transparency, where the climbing roses grow beyond the signal box and hanging baskets provide splashes of colour under the platform canopy. This contrasts sharply with the same scene, photographed only two years later from the level crossing gates. Weeds were taking over between the lines, the hanging baskets had gone and the bushes and shrubs were neglected.

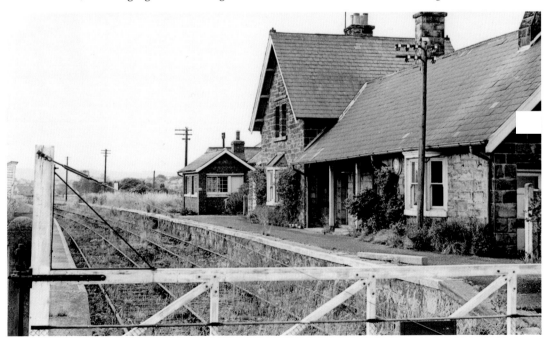

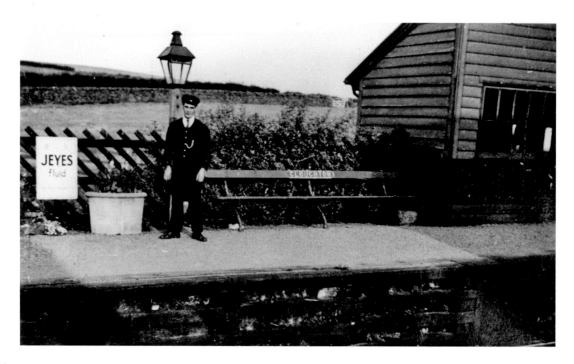

Cloughton Station: a Tale of Two Platforms

The second platform was added in 1891, when a loop line was made for passing trains. It was built of sleepers with a rubble infill as can be seen in the top photograph taken in the 1930s. The original platform, integral with the station buildings, was of substantial stone and concrete construction and most of it still survives. The later photograph, taken in the early 1960s, presents a very atmospheric view as steam blows across the platform.

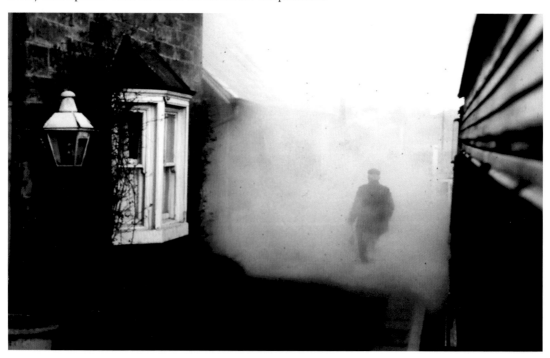

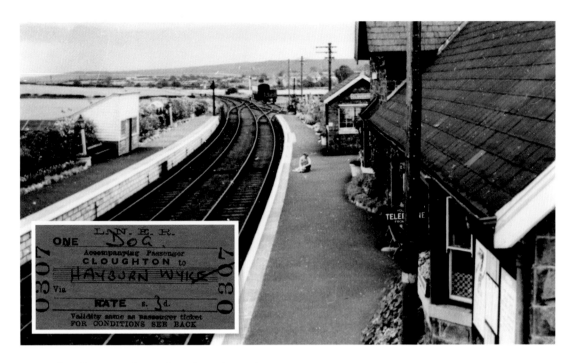

Inset ticket:

L. N. E. R.
ONE DOG
Accompanying Passenger
CLOUGHTON to
HAYBURN WYKE
Via
RATE s. 3 d.
Validity same as passenger ticket
FOR CONDITIONS SEE BACK
0307 0307

Cloughton Station: Changing Viewpoints

Looking south from the top of the signal post at the north end of the 'down' platform provided a different view of the deserted station and the wooden waiting shed on the 'up' platform. A cameraman from BBC Newcastle filmed the double-headed 'Whitby Moors Rail Tour' as it passed through the station on the last day of passenger traffic on 6 March 1965.

Inset: Just the ticket for the dog from Cloughton to Hayburn Wyke on 4 October 1960!

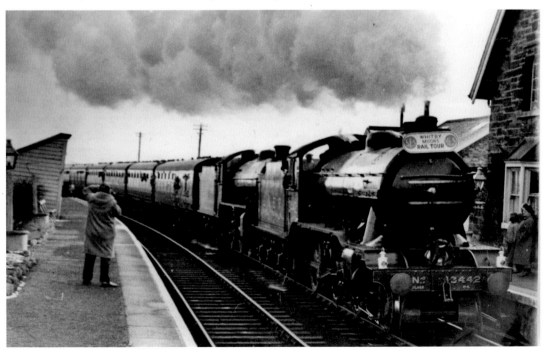

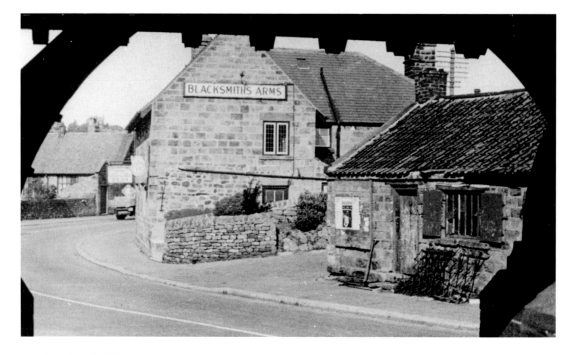

Forging Royal Links at Cloughton

The upper photograph shows the view from the gateway of St Mary's Church with the Blacksmith's Arms, centre, and The Forge on the right. In 1890 Jane Robinson was the victualler at the pub and Thomas Hodgson was the blacksmith. The lower photograph was taken on 20 May 2010 when the Queen and Prince Philip visited Cloughton. Here they are looking at a display of photographs at the entrance to The Forge accompanied by the retiring blacksmith, Alan Readman, behind Prince Philip.

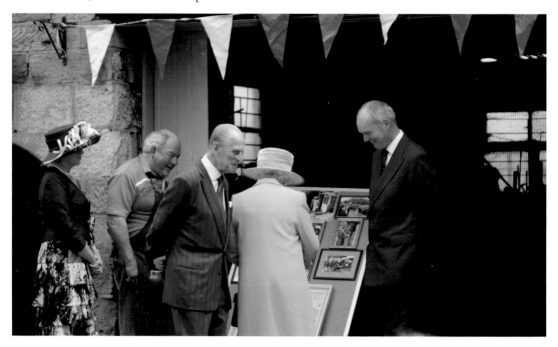

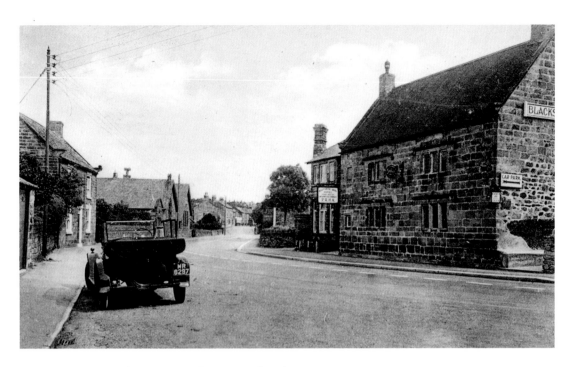

The Blacksmith's Arms, High Street, Cloughton

A popular pub and eatery the Blacksmith's Arms has seen many changes over the years and not least in the price of liquid refreshment. In 1889 supplies were bought from The Old Brewery in Scarborough when wholesale prices were – beer, 5p a gallon and bottles of Scotch whisky, 15p a bottle or 90p a gallon! The lower photograph was taken on the occasion of the visit of the Queen and Prince Philip who visited the Duchy of Lancaster properties in the area.

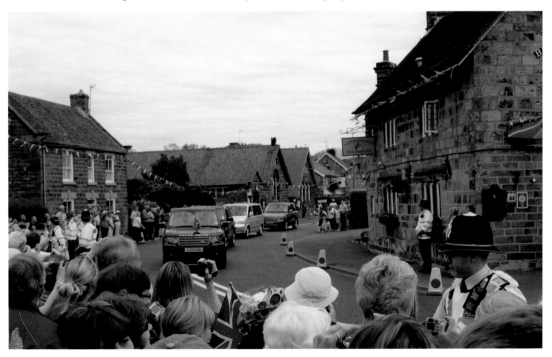

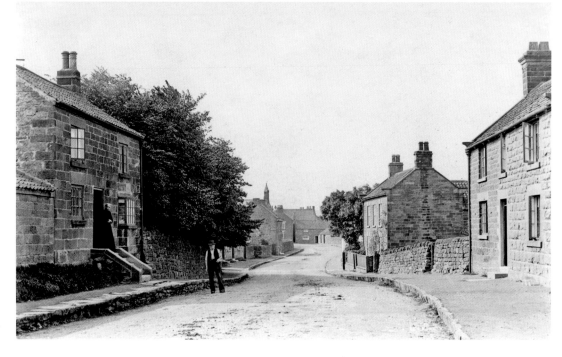

Cloughton High Street: a Royal Route

The peaceful calm of the High Street in about 1910 contrasts with the Royal motorcade as it transports the Queen and Prince Philip on their visit to the area in May 2010. The Range Rover carrying the Royal couple, and flying the Royal Standard, is turning into the entrance to Town Farm, their first port of call in Cloughton. Town Farm and the Blacksmith's Arms are part of the Duchy of Lancaster Estates that are owned by the monarchy.

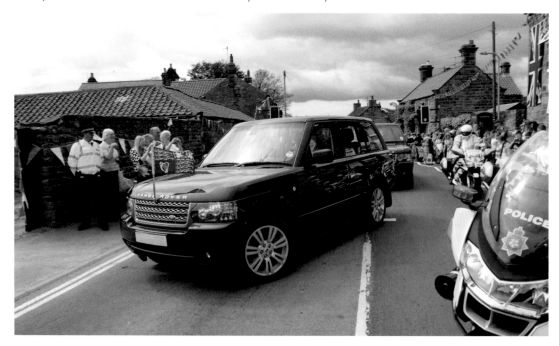

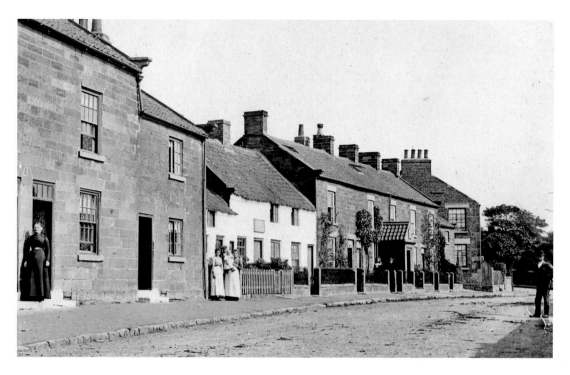

Cloughton High Street: Photographic Opportunities

This group of houses and cottages on High Street, in about 1905, has seen a few changes over the years as can be deduced by comparing these two photographs. The appearance of a camera on the street seems to have attracted the attention of quite a number of curious residents but not as many as on the occasion of the Queen's visit. Once the Royal motorcade had entered Town Farm the accompanying police outriders dispersed whilst the enthusiastic crowd waited for the Royal party to reappear.

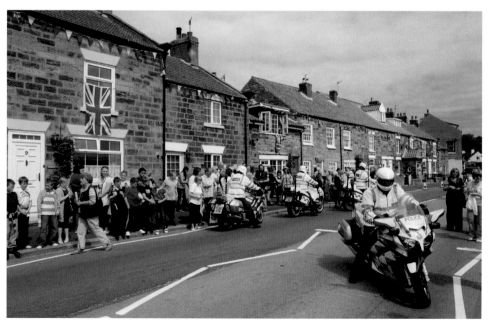

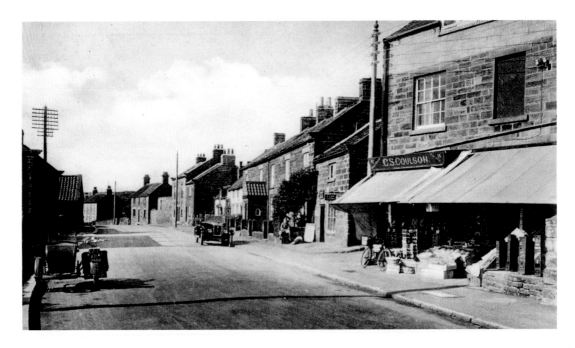

Cloughton High Street: a Shop too Far?

C. S. Coulson took over this shop in about 1926. A delivery bicycle stands outside the shop ready for speedy deliveries around the village but Carl Coulson had a Chevrolet truck to deliver orders to nearby farms and villages including Staintondale. His bill for petrol for the vehicle from the Moor Garage in August 1930 was charged at 8p per gallon! The shop was recently converted into a private residence and local residents are heading across the road to see the arrival of the Queen and Prince Philip.

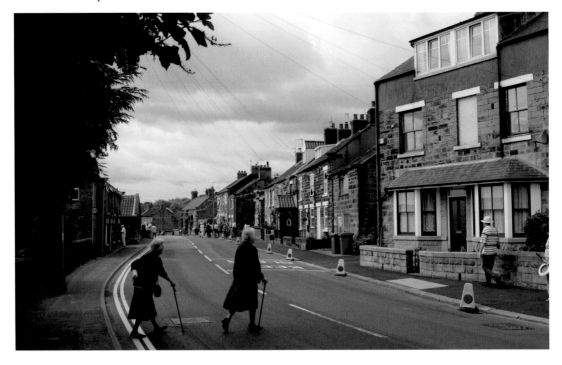

Cloughton High Street: the North End

On the left the distinctive wooden porches belonged to the pair of houses to which the Post Office was attached (see page 36). Further up the street the sign for the Red Lion Inn hangs above the hedge (see page 37). The houses and cottages on the right appear to have changed very little in the last 100 years. In the distance the road continues on up to Ravenscar whilst the A171 turns left for the moors and Whitby.

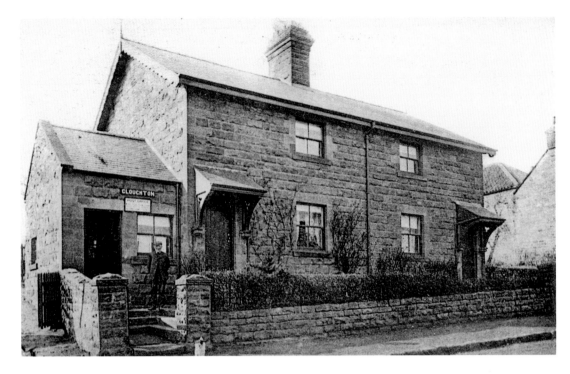

Cloughton High Street: the Old Post Office

In 1890 the Post Office was at Christopher Sedman's and John Rawlings, boot and shoemaker, was the Cloughton and Staintondale postman. The early photograph (from an old picture postcard dated 1905) shows the Post Office housed in the stone-built annex on the left. In 1932 William Sedman was the postmaster at Cloughton. The old postcard had an intriguing message – "Hope your lips won't be too rough from kissing Bell, if they are tell Aunt Annie to rub them with glycerine"!

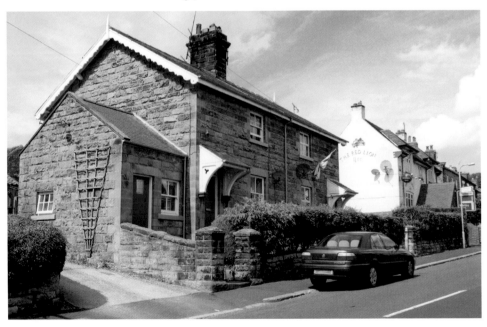

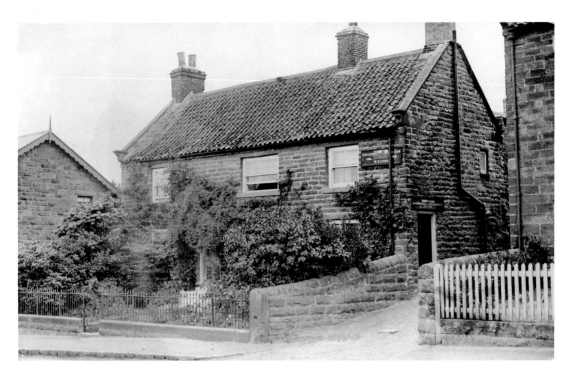

Cloughton High Street: the Red Lion Inn

This pair of photographs shows that the Red Lion has been completely rebuilt and none of the original features of the old building appear to have survived. The victualler at the Red Lion in 1890 was Robert Smith Cook whose name can still be seen on the sign on the front of the old building in about 1910. The entrance to the pub at this time was at the right hand side of the building but the rebuild has a new entrance and porch.

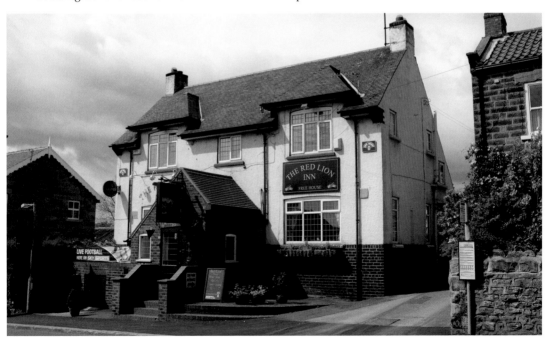

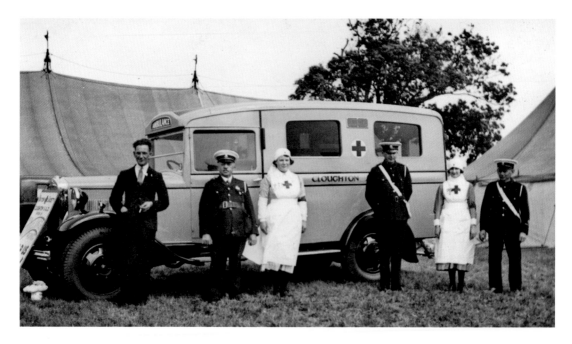

Cloughton: Taking Care of Body and Soul

Cloughton ambulance was photographed at Burniston Show (see page 22) and Bob Sollitt, on the left, ran the second garage in Burniston where the ambulance was kept when not in use. Cloughton village band was photographed in the early 1900s and it is interesting to note how the physique of some of the men seems to match up with their instruments – particularly the trombonist and the tuba player! The Domesday Book mentions Cloughton where it is spelt as the delightfully sounding *Cloctune*.

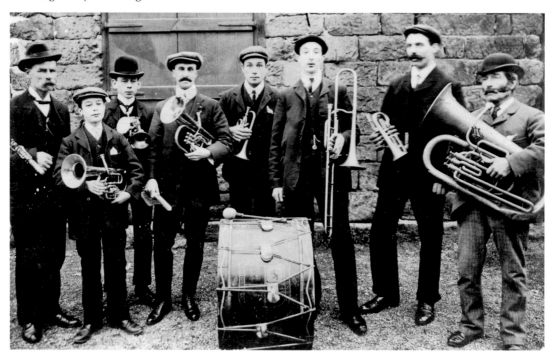

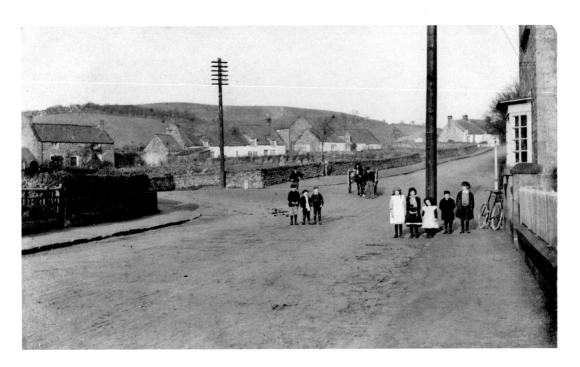

Cloughton High Street: the Parting of the Ways

At the north end of High Street the road veers left, in to West Lane, to climb up to the moors and on to Whitby. At the time the old photograph was taken the continuation of High Street up to Cloughton Newlands and on to Ravenscar appears to have been the more important and well-used route serving the nearby communities at Hayburn Wyke and Staintondale. In the angle between the two roads there was a group of old thatched cottages, which have long since been demolished or rebuilt.

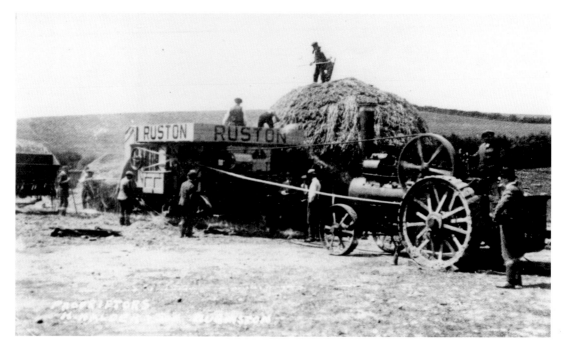

Cloughton: the Farming Scene

Steam power revolutionised farming in the nineteenth century when traction engines became the new workhorses and sets like this, belonging to H. Halder & Son of Burniston, would go from farm to farm with a threshing machine. Flocks of sheep could still be seen being shepherded along High Street, in 1932, before motorised transport made it too dangerous. Behind the shepherd is the old school and on the extreme right is the war memorial that has been relocated further up the Whitby road.

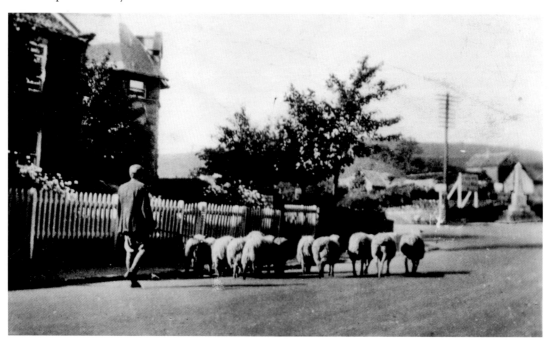

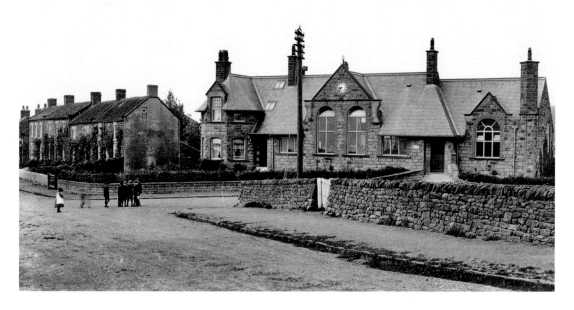

Cloughton: the Village School

The National School at Cloughton, standing on the corner of the Whitby road, was enlarged in 1872 by the addition of a classroom and in 1883 the principal room was extended. Further alterations were proposed in 1890 to provide facilities for 170 children and at this time a Mr Tom Appleton was the schoolmaster. Accommodation for the schoolmaster was provided in the bow-fronted section on the left with its own separate entrance. It has now been converted into residential accommodation.

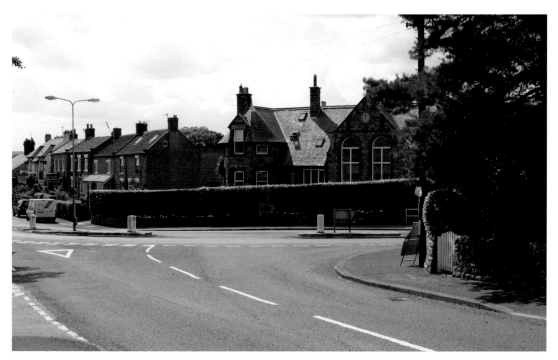

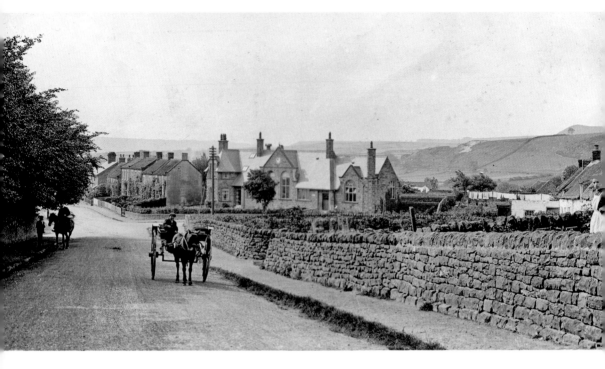

Cloughton: from the Newlands Road

Cloughton National School, in the centre of this photograph, is now hidden by bushes and trees in the gardens of the new houses and cottages in this area. The old white-washed cottages, long since demolished, can be seen on the extreme right in the early photograph that also shows a delivery cart heading up the road to outlying houses and farms. The lady behind the wall is probably the same one standing outside her cottage on the photograph on the opposite page.

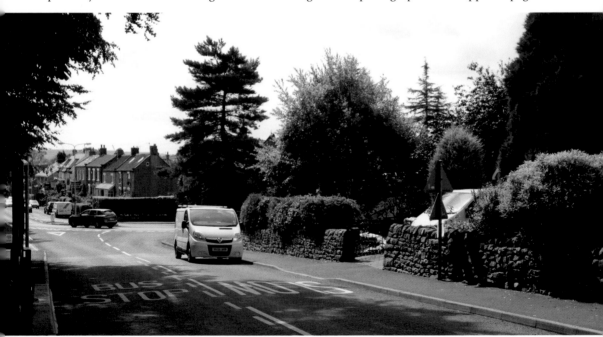

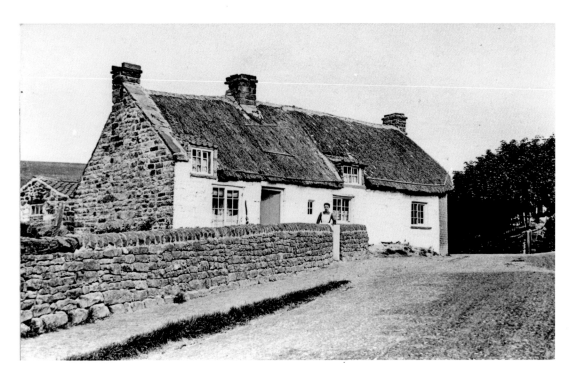

Thatched and Despatched at Cloughton

These cottages, opposite to the entrance to Cober Hill, are thought to have been the last thatched cottages in the village. They were demolished to make way for the new houses and bungalows seen in the recent photograph. Behind the old cottages there was a well, marked on the Ordnance Survey plan of 1852. It was called Tea Well or Town End Well and later came under the control of the Cloughton Waterworks Company.

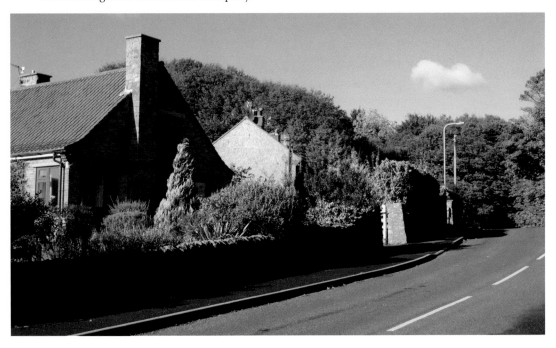

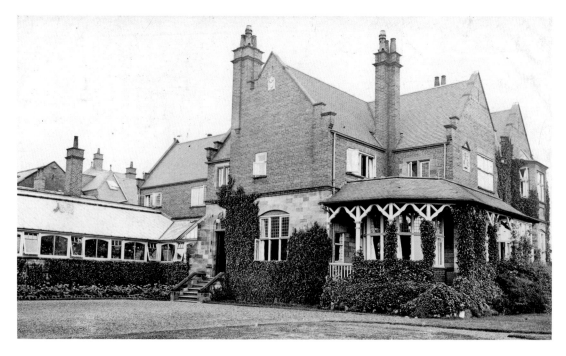

Cloughton: Cober Hall

Cober Hall was once the residence of the advocate Sir Frank Lockwood who was a great practical joker. He used to send telegrams announcing the arrival of unexpected guests and would then create great consternation by appearing very put out, organising bedrooms, complaining about how upset he was and threatening to leave. When the whole house was in a state of agitated chaos he would own up to his deception amidst great relief and laughter in the household.

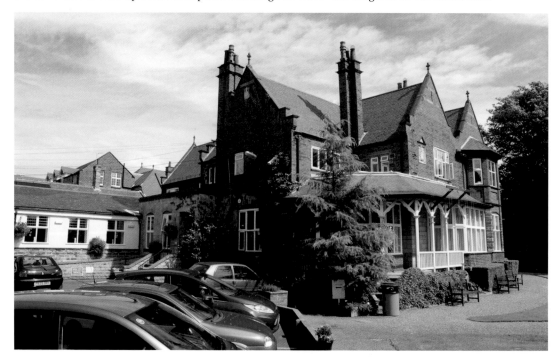

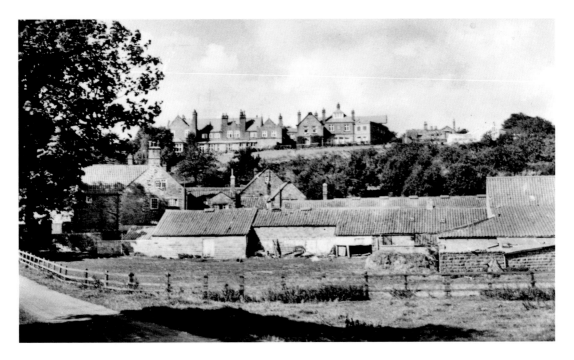

Cloughton: Cober Hill and Court Green

Cober Hill, as it is now known, sits on a hill overlooking Court Green, on the left, and the extensive buildings of Court Green Farm. Cober Hill is now a centre for refreshment and inspiration and caters for individuals, families, groups, and schools and also provides conference facilities. In the foreground, Salt Pans Road runs down from Cober Hill, past Court Green and over the railway bridge in the foreground, to the beach at Cloughton Wyke (see page 47).

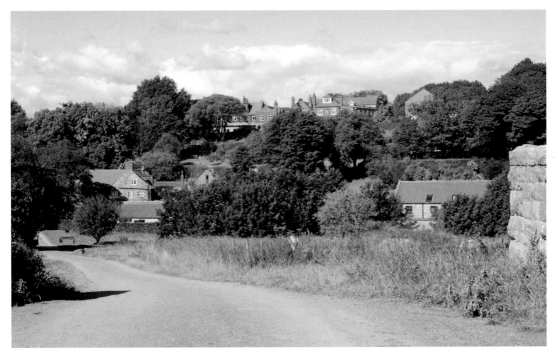

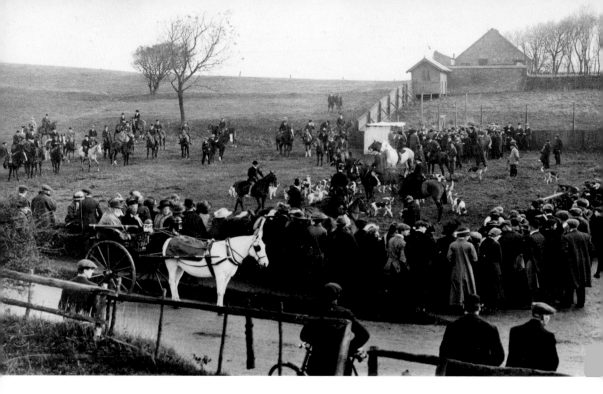

High Days and Holidays at Cober Hill

Various activities used to take place in the fields below Cober Hill – the upper photograph shows the opening meet of the Staintondale Hounds at Cober Hill in 1913 (see page 63). Later an extensive collection of wooden bungalows were available, in the 1930s, for holidaymakers looking for simple accommodation but only a few years later prisoners of war would be housed in camps like these, but with a higher fence!

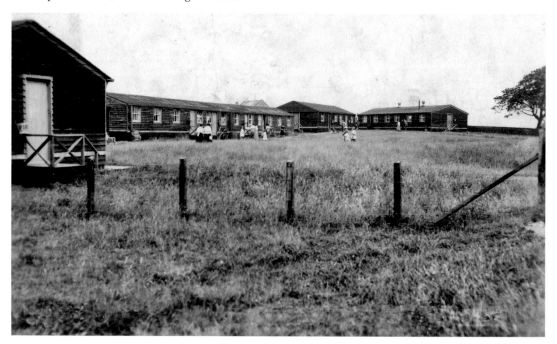

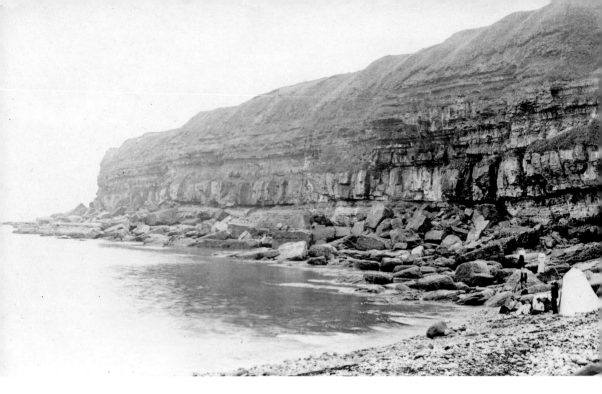

Cloughton Wyke: a Glorious Coast

The bay at Cloughton is one of the little-known gems of the Yorkshire coast and its rocky cliffs and shore have changed very little over the last century. It has however seen some spectacular strandings on the beach as can be seen in the next two pages. The path on the right, in the lower photograph, is part of the Cleveland Way that starts at Helmsley and includes the Yorkshire coast between Saltburn and Filey.

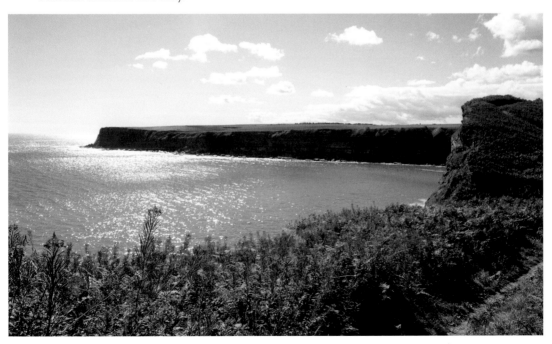

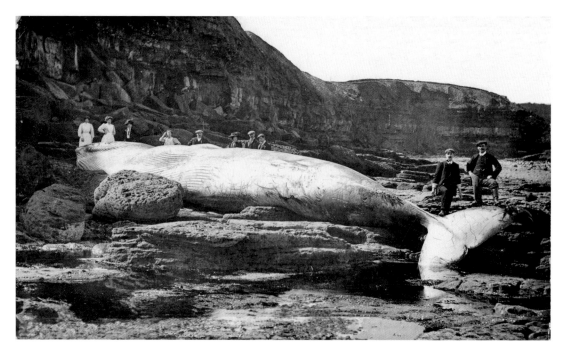

A Whale of a Time at Cloughton

In March 1910 this whale washed ashore in Cloughton Wyke and became stranded high up the beach. A Lesser Rorqual it measured 51 feet long and, a rare occurrence, it proved of great interest to local people. It was quite a surprise when, in September 1910, another whale carcass washed ashore (lower picture) and this was even bigger at 72 feet long. Local people remembered that their relatives at Brompton, nine miles away, could smell the whale when the wind was in the wrong direction!

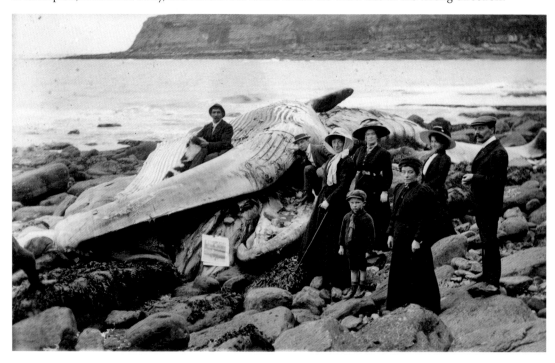

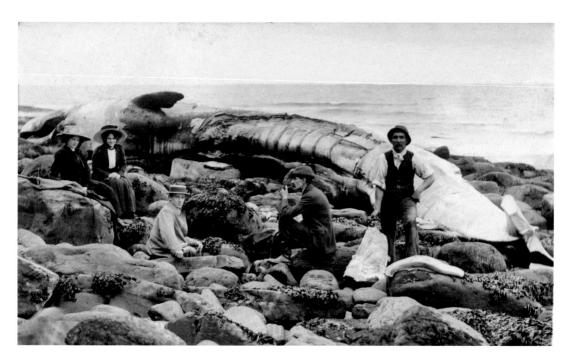

A Weighty Problem Solved

Sometimes stranded whale carcasses wash out to sea on a subsequent high tide but unfortunately this was not the case with these two and a solution had to be found for their disposal. In the top photograph Mark Bennett (standing), assisted by Christopher Riley (with pipe), cut up the September whale. The chunks of whale were hauled up the cliff, by rope and pulley, to be buried in the fields with lime brought by horse and cart from Seamer.

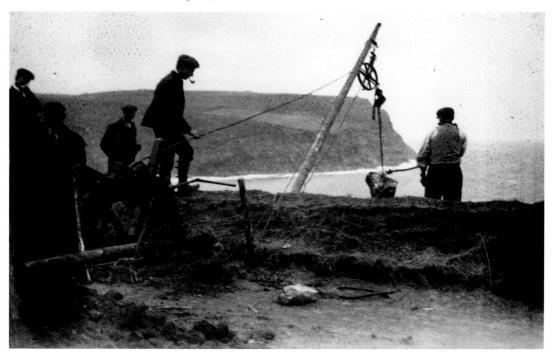

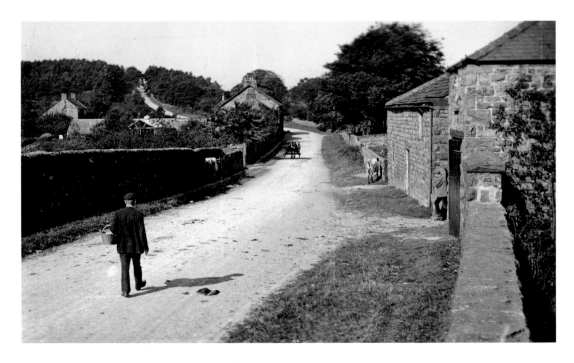

Cloughton Newlands Road and the Bryherstones

On the left, in the old photograph taken in the 1920s, the Newlands Inn stands next to Newlands Road leading up to Staintondale and Ravenscar. In 1890 Robert Crossland was the victualler and market gardener here. The Inn is now called the Bryherstones after a racehorse. There were six farmers listed as living at Cloughton Newlands in 1890 and their main crops were wheat, oats, barley and turnips. Now many farms in the area seem to concentrate on more lucrative livestock.

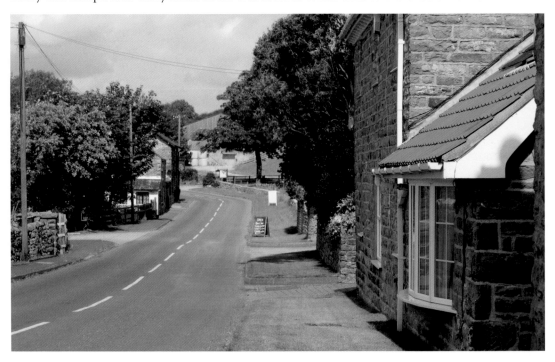

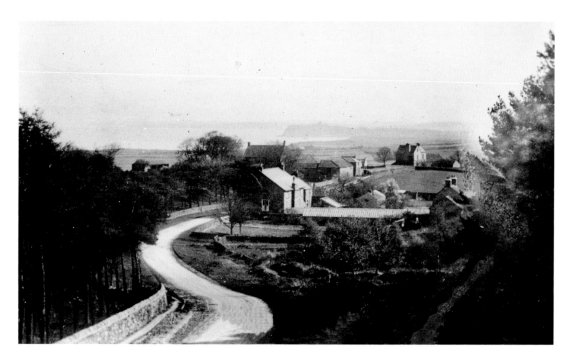

Making a Pig at Cloughton Newlands

Further up the Newlands Road towards Hayburn Wyke the old view, looking back towards Scarborough Castle headland, shows the Newlands Inn and some of the larger houses. One holidaymaker here wrote home in 1910 – "I thought I'd send a postcard of the house, it's a lovely place, they have a Jersey cow, 2 pigs, 3 ducks, which by the way only one remains as we've had two for dinner. Now we are tackling the hens, having one roasted tonight. I'm getting very corpulent I'm afraid"!

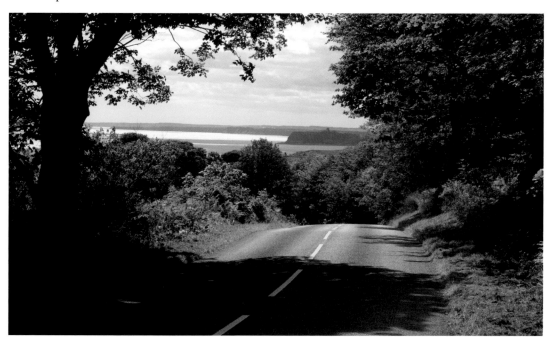

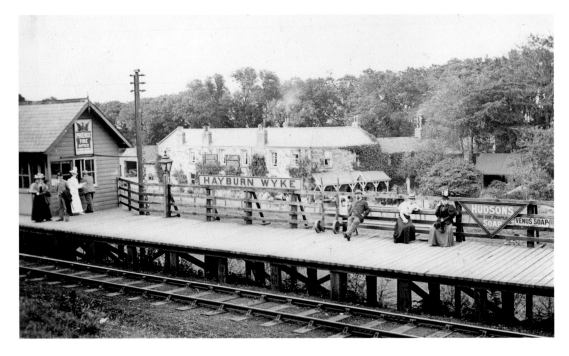

Hayburn Wyke: a Changing Station

Originally the station at Hayburn Wyke, built entirely of wood, was on the hotel side of the line when it opened in 1885. In 1893 a new platform, of brick and concrete, was built on the opposite side of the line and the wooden buildings transferred across (see pages 54-55). At the same time a station master's house was built, at the north end of the station, and this can be seen on the right in the lower photograph.

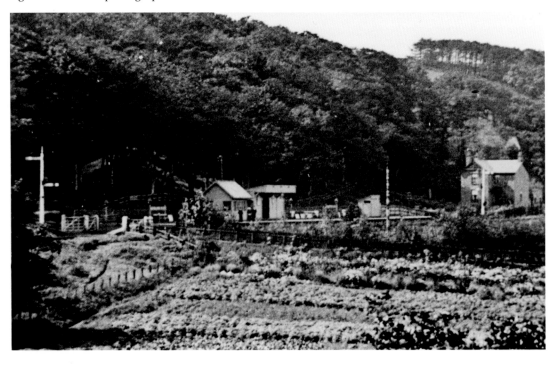

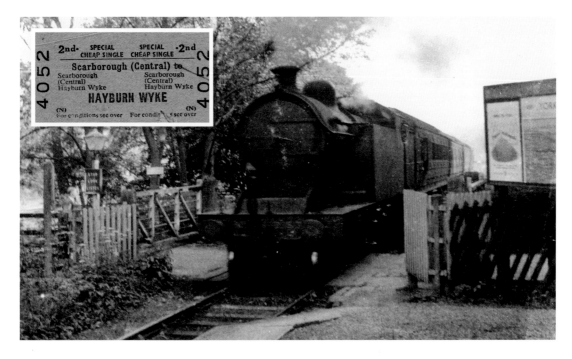

Hayburn Wyke Station: on the Level

The level crossing at the south end of the station was on the private road leading to the Hayburn Wyke Hotel. It was the scene of a tragic accident in 1957 when a goods train collided with a Ford Prefect van pushing it the full length of the platform and killing both the occupants. There is little trace of the station now as only the much overgrown platform remains.

Inset: a ticket from Scarborough to Hayburn Wyke dated 27 February 1965.

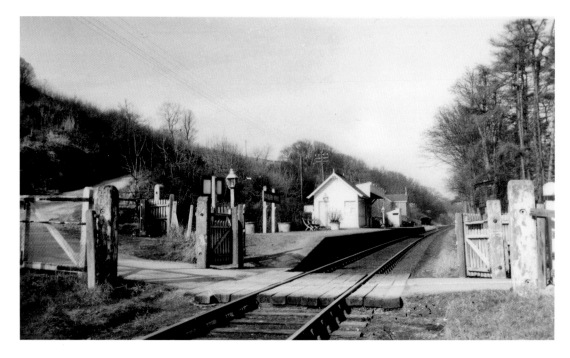

Hayburn Wyke Station: Nature takes Over

Looking north from the level crossing this neat and tidy station was the smallest on the line as it served a very small community consisting largely of the Hayburn Wyke Hotel and adjacent farm. It was a very popular station with day-trippers and picnickers as it gave access to a very picturesque part of the coast. It had been a popular horse-ride from Scarborough as early as 1829, long before the railway arrived in 1885. On the right a stone gatepost survives, covered in ivy.

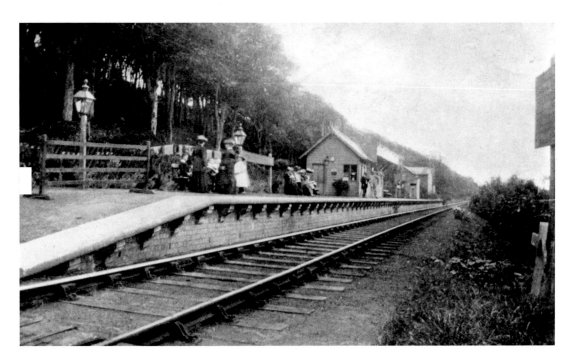

Hayburn Wyke Station: Looking Both Ways

Two opposite views of the station: the earlier one, from the south, showing a busy scene in about 1904. In 1886 monthly traffic figures revealed that the lowest number of passengers buying tickets here was 78 in January and the highest 453 in August but this did not take into account the thousands of return tickets booked to the station from Scarborough, Whitby and places further afield. Sixty years later, viewed from the north, the station appears to be deserted shortly before closure.

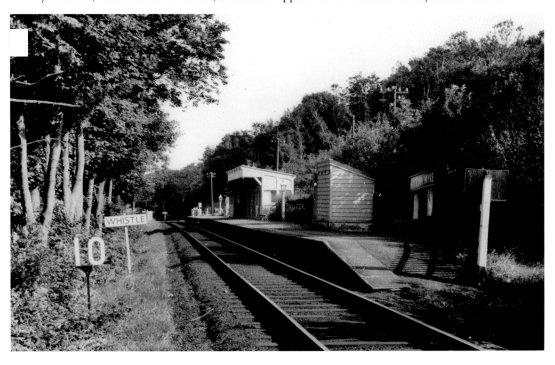

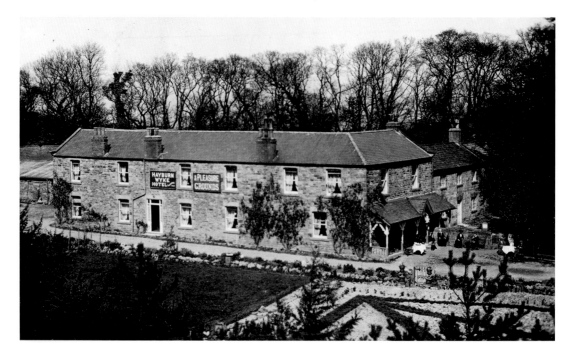

Hayburn Wyke Hotel and Pleasure Gardens

This hotel was once a coaching inn on the old road from Scarborough to Whitby. After the railway arrived the hotel advertised the local attractions – 'Hayburn Wyke with its rugged sea beach, picturesque waterfalls, extensive woodland scenery, combined with romantic and charmingly secluded walks, trout fishing, lawn tennis and athletic grounds, comprises upwards of 200 acres of pleasure ground unrivalled in the district.' The area in front of the hotel is now a car park and part of the pleasure grounds now caters for children.

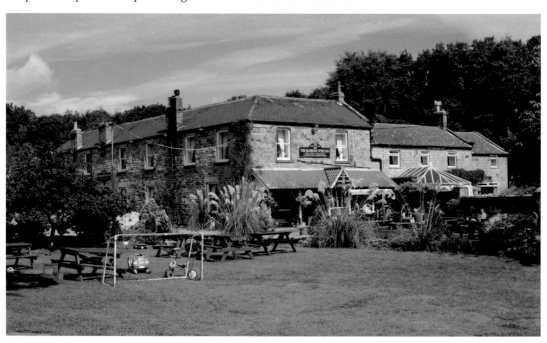

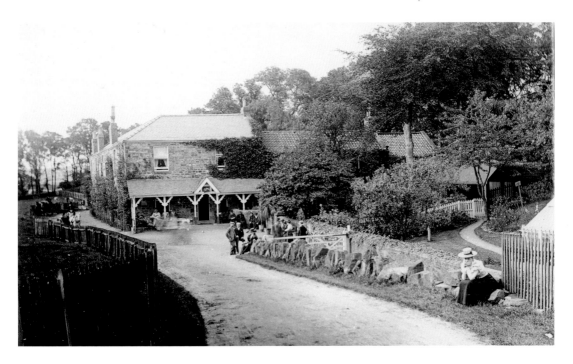

Hayburn Wyke: Travelling in Style

Visitors to Hayburn Wyke not only arrived by train in the early 1900s, they also travelled by North Eastern Railway charabancs from 1906 to 1914. The NER ran charabanc tours from the forecourt of Scarborough Central station. The sixteen-mile round trip cost 2/6d (12½p). In 1913 the NER provided a series of eleven delightful motor tours leaving Scarborough at 10.15am and 2.15pm. The vehicles were limited to a maximum speed of 12mph and carried about 30 passengers but hopefully they all sat down before they set off!

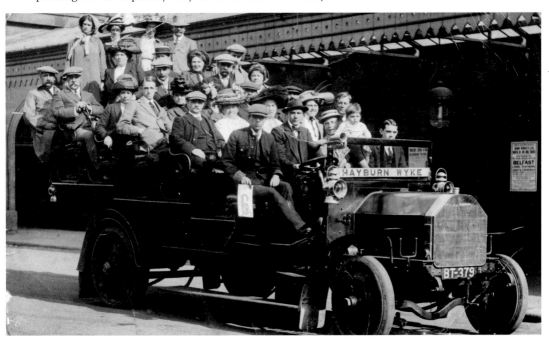

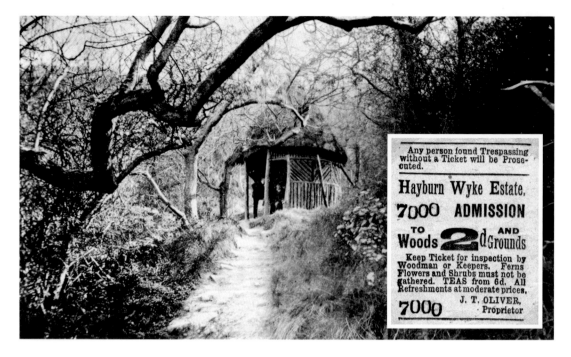

Hayburn Wyke: if You Go Down in the Woods...

In 1829 it was recorded that a rustic hut had been built in the woods at Hayburn Wyke but this summerhouse must be a later successor. Another feature of the woods, of which there is very little trace, was the stone quarry operated by John Waddell & Sons who built the Scarborough & Whitby Railway in the early 1880s. Stone from this quarry was probably used to build the stations at Scalby, Cloughton and Staintondale as well as the clock tower at Scarborough station.

Inset: A charge was made for access to the woods.

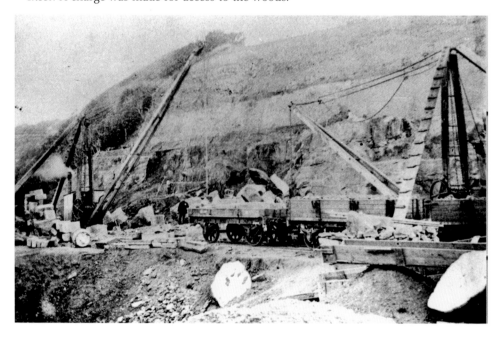

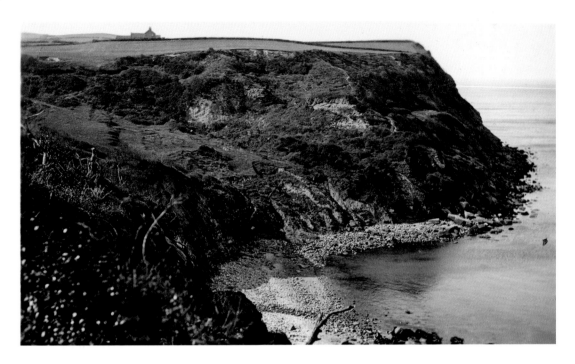

Hayburn Wyke: a Beautiful Bay

In the Scarborough & Whitby Railway guide of 1897 this area was described as – "A thickly wooded, sheltered inlet on the coast, possessing features of peculiar beauty and grandeur. Descending from the station by winding pathways in the midst of rich sylvan scenery, every step is beset with the most charming views. On the beach an exceedingly pretty waterfall finds its way over the cliff. The undercliff here is of remarkable beauty, being densely wooded and rich in foliage, while grass-grown pathways abound, making the whole cliff easy of access."

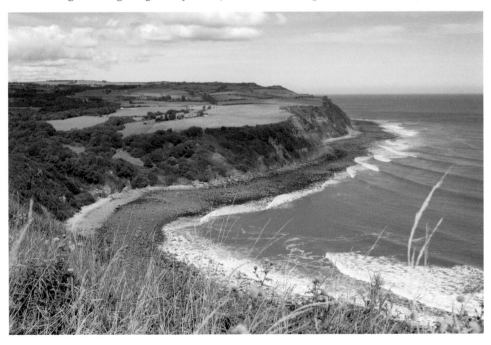

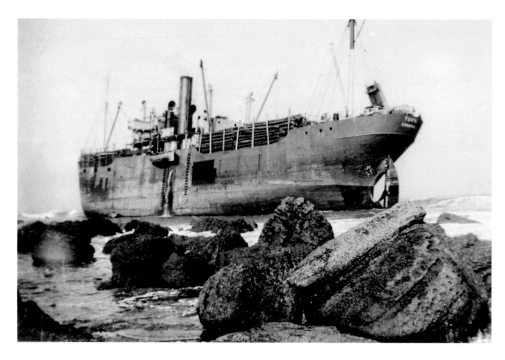

Hayburn Wyke: Pit-props Galore!

The heavily-laden *Torni* was carrying a cargo of pit-props from the Baltic to Hartlepool in 1946. In thick fog the vessel narrowly missed a racing yacht and ran aground in Hayburn Wyke. Part of the cargo had to be thrown overboard in order to refloat the vessel. The pit-props became a serious hazard, to the local coble fishermen, as they floated along the coast, whilst others became stranded on the beach. The wooded area on the right was the site of the quarry (see page 58).

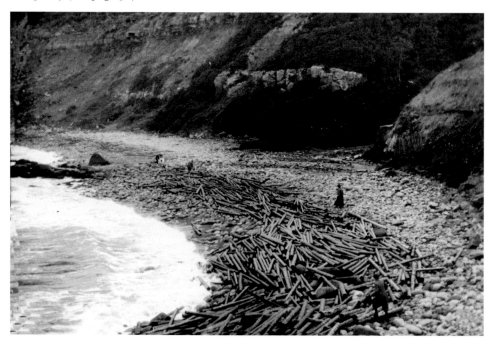

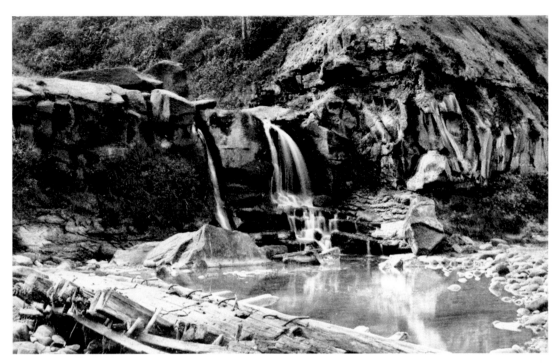

Hayburn Wyke: the Waterfall

This waterfall, a rare feature along the North Yorkshire coast, was one of the main attractions at Hayburn Wyke but its appearance changes with the seasons, and the quantity of rain. The upper view was taken in about 1907 and the lower one in the winter of 1931. This area is now a Site of Special Scientific Interest because of the variety of plants and animals found here.

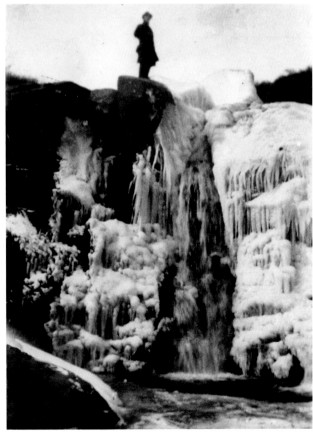

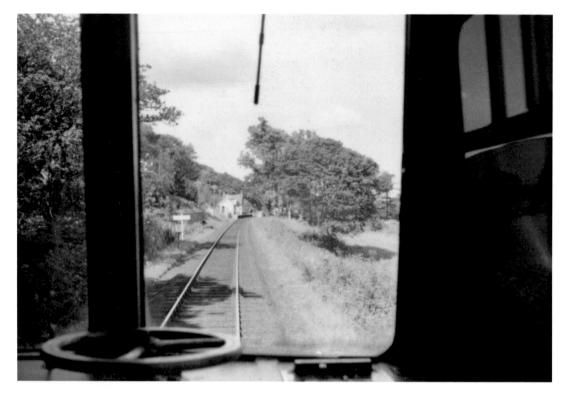

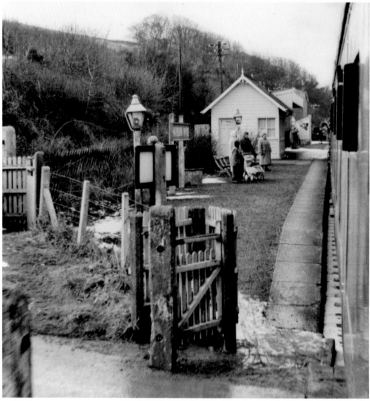

Approaching Hayburn Wyke Station: the End of an Era
The view through the driver's cab of a Diesel Multiple Unit provides an unusual glimpse of Hayburn Wyke station from the south as this whole area is now shaded by tall trees. DMUs were introduced on the line in 1958 and, with all-round windows, provided better views of the magnificent scenery through which the trains passed. The lower view was taken on the last day of passenger traffic on the line, on 6 March 1965, from the double-headed steam-hauled 'Whitby Moors Rail Tour' (see page 29).

Staintondale Hunt at Hayburn Wyke

The kennels of the Staintondale Hunt were at Hayburn Wyke as seen in the centre of the upper photograph taken in about 1920. Below, the master of the Hunt looks fiercer than most of his hounds! In 1794 the *Sporting Magazine* recorded a severe chase run by the local gentlemen farmers when forty horsemen and forty dogs chased a fox for about sixty miles. Only two horsemen and four dogs were in at the kill and several of the horses died that evening.

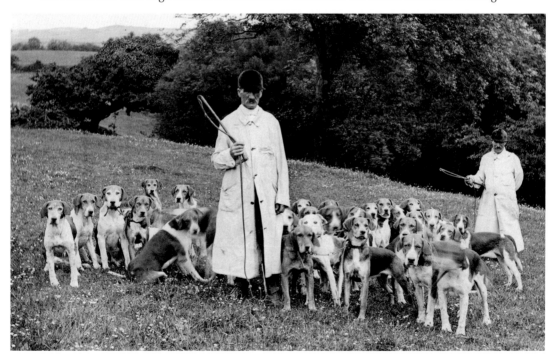

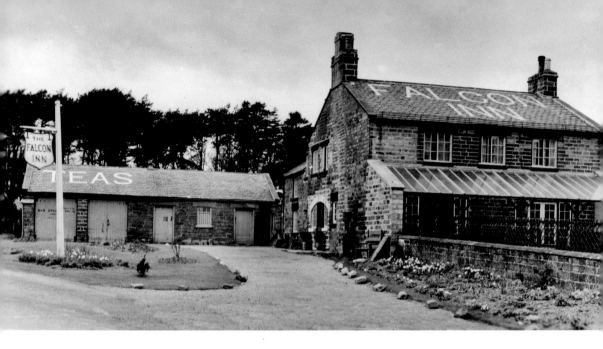

The Falcon Inn, Cloughton Moor

The Falcon Inn has been a popular refreshment stop, on the Scarborough–Whitby moor road, for many years. Joseph Cockerill was recorded as the victualler here in 1890. In earlier years the stage coach 'Royal Union' left Scarborough every evening at 5pm and another, 'Diligence' went to Whitby twice a week. The stables for the horses, on the left, have been converted into a dining room and the Falcon Inn is still a welcome sight especially on a late summer evening after a thirst-making walk!

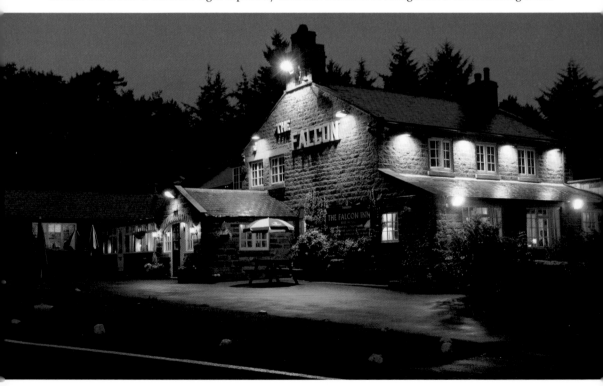

Staintondale by Road, Rail and Gentle Giants

On the left is the road through Staintondale and on the right the sharp curve of the railway line as it makes its way through the dale. The old railway track passes close to an attraction in the area that has been entertaining and enthralling adults and children for twenty-five years. The award winning Staintondale Shire Horse Farm is run by Tony and Ann Jenkins who put their Shire Horses and Shetland ponies through their paces in a natural environment.

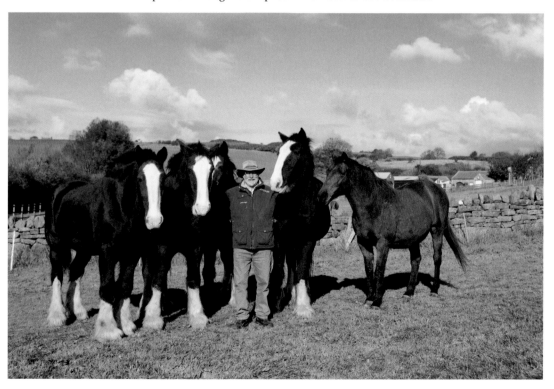

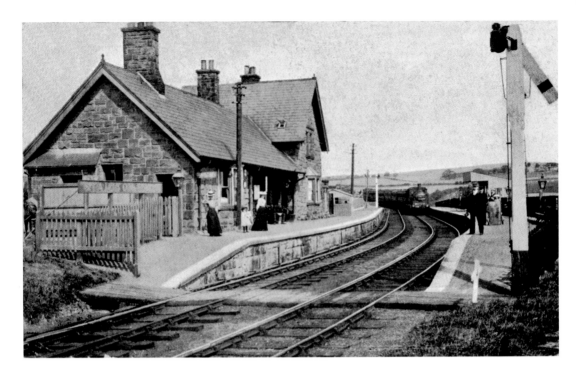

Staintondale: Four Changes Through Time...

This series of four photographs, on this and the next page, show the changing scene at Stainton Dale station over the century from 1910 to 2010. Above, passengers wait for the train to Whitby as the train for Scarborough approaches. In the lower photograph the push-pull train to Scarborough stands just short of the newly extended platforms at the south end of the station. The new section of brickwork of the platform on the left stands out clearly below the platform edge.

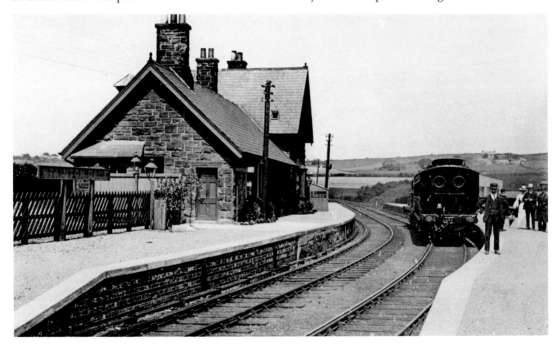

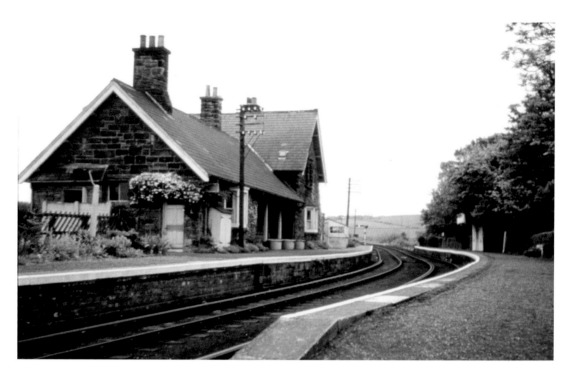

...at Stainton Dale Station

Shortly after closure in 1965 the trees and bushes were beginning to take over but the track, little wooden signal cabin and the signals were still *in situ*. These were removed in 1968 and the lower photograph shows the present day scene where both platforms have survived (unlike Cloughton, page 26) and the track-bed is now part of the walking and cycling route between Scarborough and Whitby. The station buildings and platforms are now privately owned.

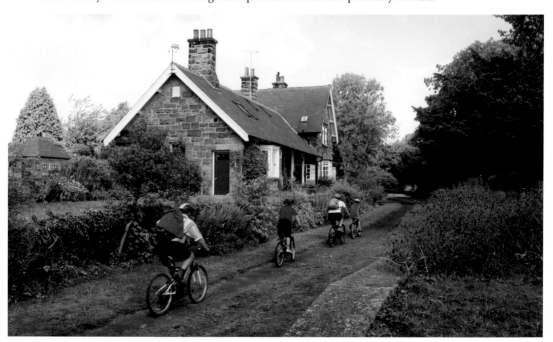

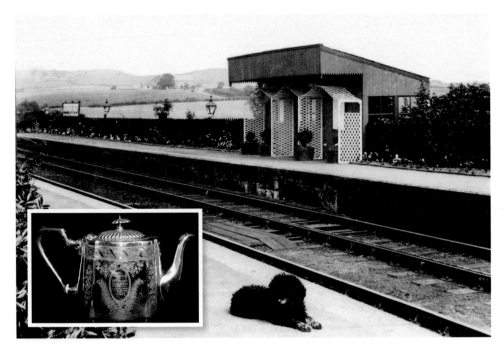

On the Platforms at Stainton Dale Station

A standard design North Eastern Railway platform shelter was to be found at most of the stations on the Scarborough & Whitby Railway. The one here at Stainton Dale, in about 1916, appears to have been embellished with the addition of three trellis archways and potted shrubs, the work of the station staff. The lower photograph shows the last stationmaster, Mr R. W. Carr, awaiting the arrival of a DMU as it approaches from Whitby

Inset: a beautifully inscribed teapot presented to the first stationmaster, Mr T. Wright.

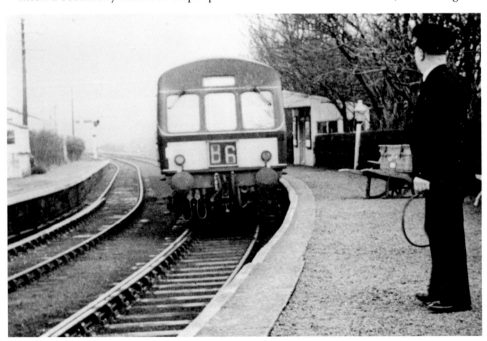

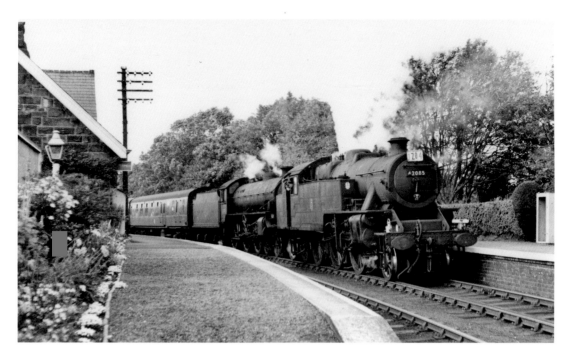

Stainton Dale Station: Vanishing Steam

When Diesel Multiple Units were introduced in 1958 the only trains still worked by steam locomotives were the summer excursion trains from York, Leeds and other parts of the area. The illustration shows a double-headed steam-hauled excursion passing through the station in August 1961. Now the rails have gone, the steam has long since evaporated into the clear blue skies and vegetation has taken over the track-bed and platforms.

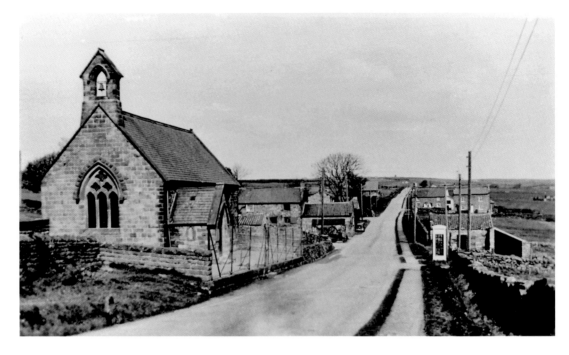

Staintondale School

The first building that stands out on the approach to Staintondale is the former village school. Looking more like a church it is recorded that in 1832 a schoolroom was built here that was used for the threefold purpose of a chapel of ease, a Methodist chapel, and a schoolroom with accommodation for eighty children. Despite its conversion, with the addition of sympathetic dormer windows, a bell still hangs above the roof of the building but it no longer summons children of the dale to their lessons.

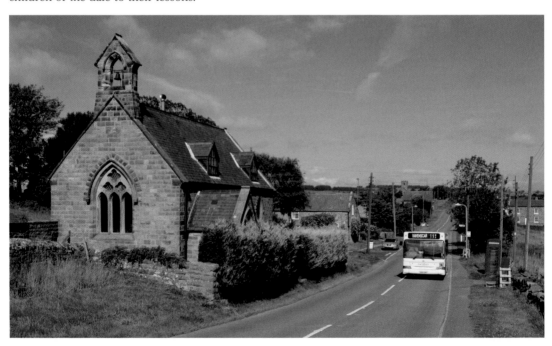

Staintondale: a Quaker Connection

The Quaker faith was strong in Staintondale in the seventeenth and eighteenth centuries and George Fox, the founder, was in this area in 1651 and for a time was imprisoned in Scarborough Castle. Meetings were held in the cottage of William Warfolk but by 1690 a Meeting House had been built alongside the cottage. This was later enlarged but was sold in 1803 and subsequently demolished. Meetings continued to be held in Warfolk Cottage and were well attended judging by the photograph taken in June 1913!

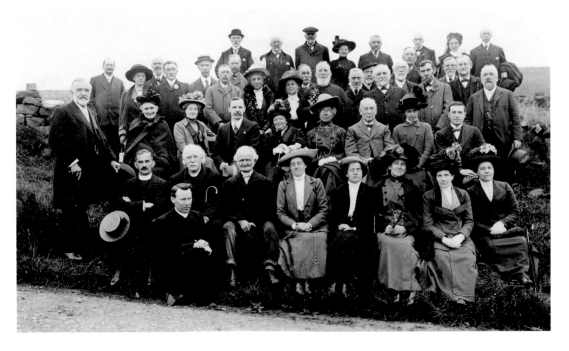

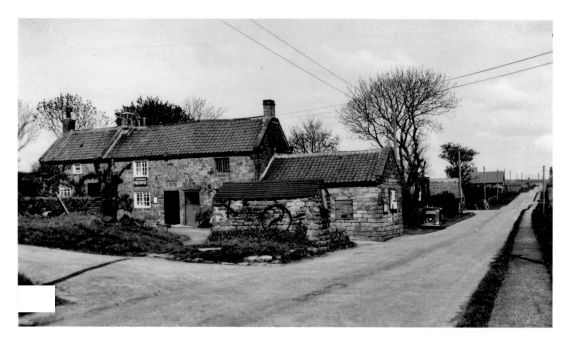

Staintondale: the Old Forge and Post Office

The Old Forge next to the road in the upper photograph, taken in about 1944, was demolished to allow the road to be widened. The two-storey section adjoining the forge contained a stable and the village Post Office as seen in the close-up below. A large grindstone stands outside the stable for sharpening scythes and other items of agricultural machinery. William Ward was the blacksmith here in 1890 and Mr J. Ward held that position in 1932 when Mrs Ward was the postmistress.

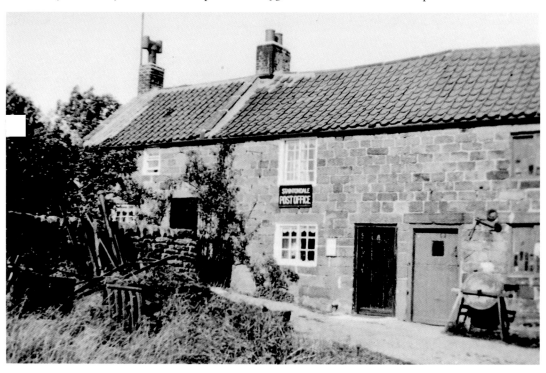

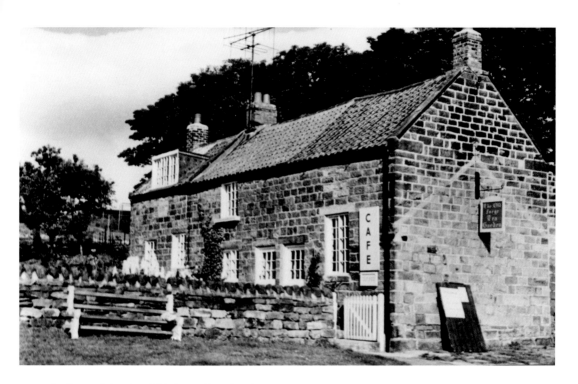

Staintondale: the Old Forge Tea Garden

The line of the roof of the demolished forge can be seen on the end of the building and the stable was converted into a café and the yard into a tea garden. The building now houses the village shop. On the site of the garden the blacksmith used to fit the metal tyres on the wooden cart wheels. This was done on a circle of stones where the tyre was heated by burning peat turves. When the iron hoop had expanded the cart wheel was dropped on and tapped into place.

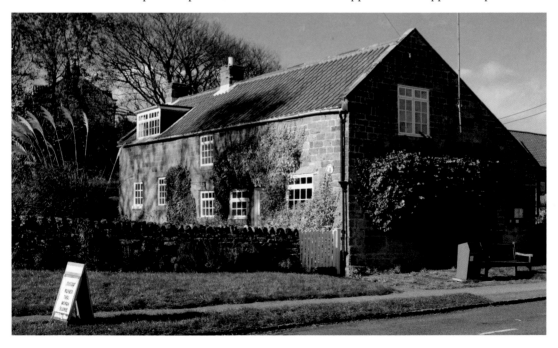

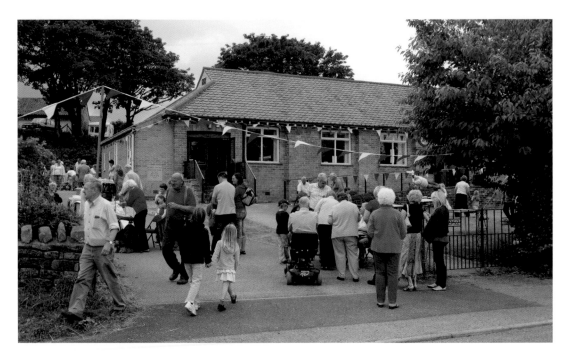

Staintondale Show: at the Village Hall

A popular annual local event is the Staintondale Show held at the village hall. In 2010 the weather was kind, the wind light and many people turned out to enjoy the occasion. There was a good show of vegetables, fruit and flowers in a marquee in front of the hall and a show of crafts and baking in the hall itself. Local organisations and businesses were represented on stalls round the back including the local Coastguards. See page 22 for Cloughton and Burniston shows.

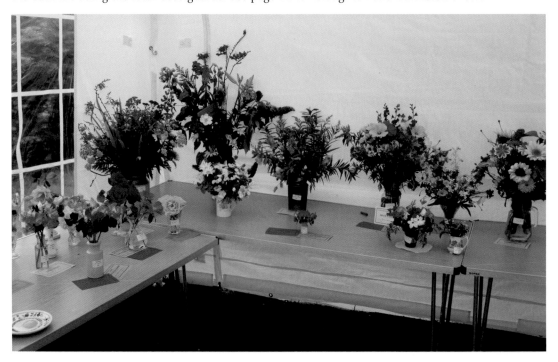

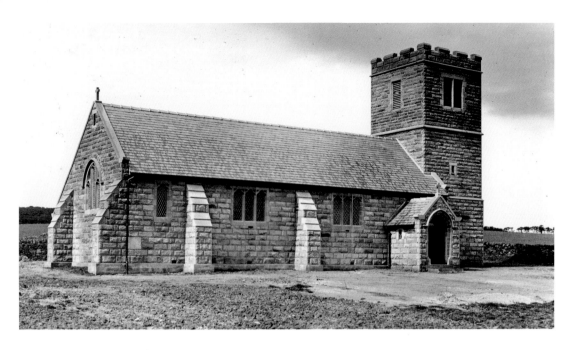

Staintondale: St John's Church

St John's Church at Staintondale is a relatively recent building having been erected in 1928 the old photograph being taken shortly after it had been completed. The corner stone of the church records that it was "laid by The Most Rev. Cosmo Gordon Lang, Lord Archbishop of York on July 14 1928". The church stood all alone without a single gravestone but now the graveyard is slowly beginning to serve its intended purpose. The population of Staintondale (Stone-town) in 1881 was 238.

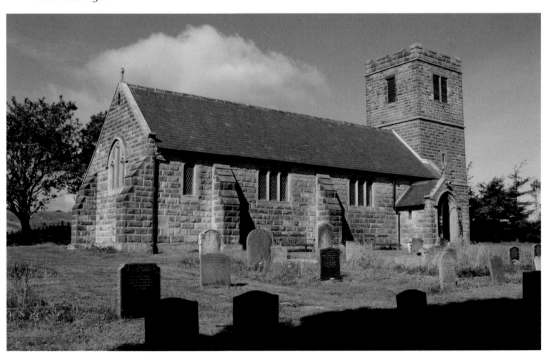

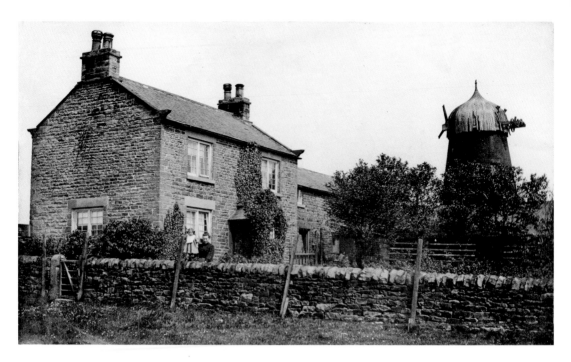

Ravenscar: Mill Farm

When a daughter of the owner of Raven Hall got married in 1858 it was recorded that the workmen of the estate were fed at a "mill in the course of erection near the moors". A postcard of the mill dated about 1910 bears a message – "Old Flour Mill about 15 minutes walk from the hotel (Raven Hall) it is now useless as a mill". The lack of sails would seem to confirm the writer's diagnosis! The old farmhouse is now a holiday cottage.

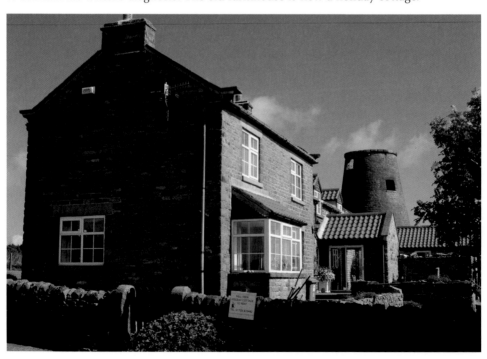

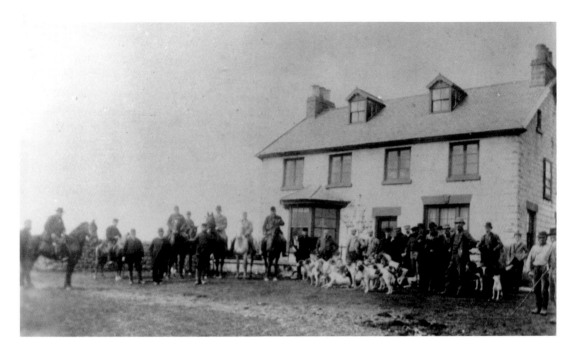

Ravenscar: the Blue Robin

The old photograph shows the meet of the Staintondale Hunt outside the Raven Hill Inn in 1891 when Mrs Jenny Thompson was the victualler here. The Raven Hill Inn later became known as the Blue Robin because of the dress of the proprietress. More recently some thought that it was the colour the local robins turned because of the inclement winter weather! The building is now called Smugglers Rock and provides bed and breakfast, and self-catering cottages.

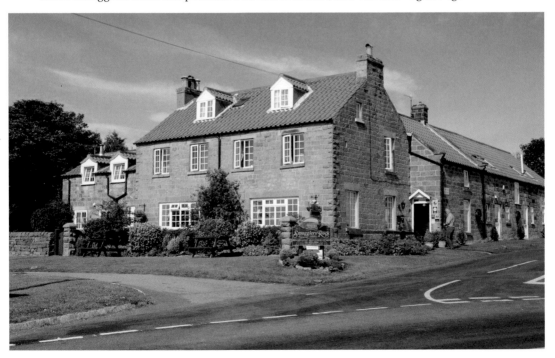

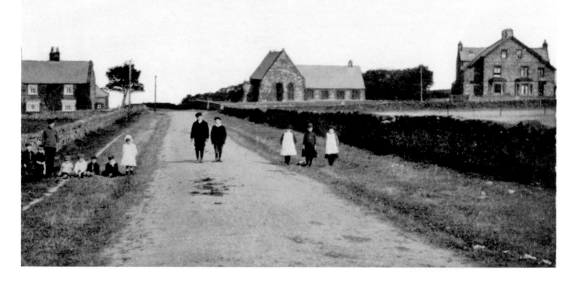

Ravenscar: St Hilda's Church and the 'Madding Crowd'

The message on this old postcard dated 1910 reads – "One cannot get much here – only one shop – at which I could not even get a pair of shoelaces". The view has hardly changed in a hundred years – on the left is High Peak Farm, in the centre St Hilda's Church and on the right Church Villas. In the 1898 guide Ravenscar was described as having air that was unrivalled in England, and the absence of the 'madding crowd' – certainly this little crowd of locals look fairly quiet!

RAVENSCAR.

AVENSCAR in its artificial as opposed to its natural aspect, consists of the station, the Raven Hall Hotel, the church of St. Hilda, licensed by the Archbishop of York for Divine Service, capable of holding a congregation of eighty, and some two dozen houses built on the land of the Ravenscar Estate Company; this Company are the owners of what is now known as Ravenscar, and have laid out the estate, made the roads and drains, provided a water supply, and have generally speaking made the necessary beginnings of a health resort, perhaps of a popular one in the distant future.

Attractions.

The air is perhaps unrivalled in England, and of the absence of the "madding crowd," typical of the popular watering place, there cannot be the least doubt.

Scenery.

The view of the sea and cliffs to be obtained from the Terraces has already been mentioned— looking inland towards the open stretch of Moors, there is a magnificent

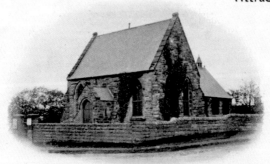

CHURCH OF ST. HILDA, RAVENSCAR.

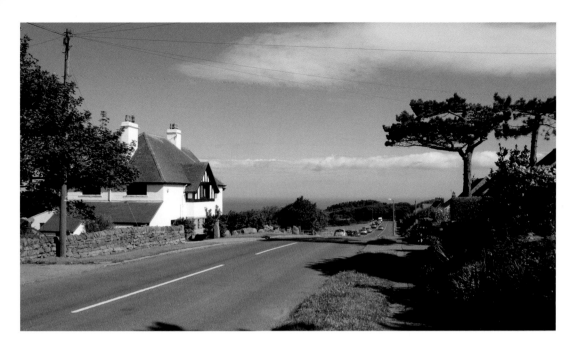

Ravenscar: Raven Hall Road

This road was built in 1829 when the Lady of the Manor had a private road laid out from the highway near Mill Farm to the gates of her residence at Raven Hall. On the left one of the earlier houses constructed by the Ravenscar Estate Company (see page 83) was marked on the Estate Plan of 1918 as "New Villa". This building, known as Crag Hill Villa, was illustrated in the auction catalogue for 2 July 1910.

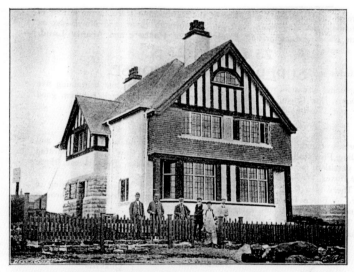

AT THE CORNER OF RAVEN HALL & CRAG HILL ROADS.

LOT **4** A charmingly situated and well-designed **Freehold** 753
Detached Villa Residence, known as and 754
" Crag Hill Villa," erected according to the plans and under the
supervision of an eminent architect, and which will be sold
with **vacant possession.**

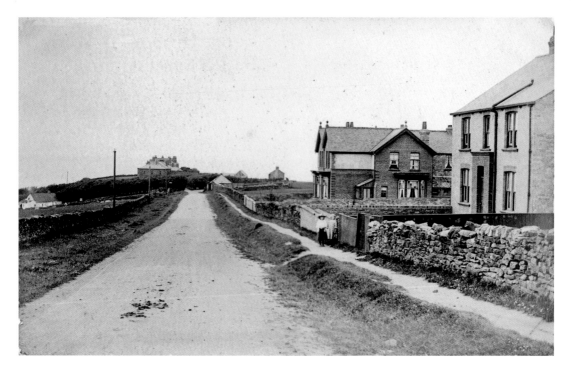

Ravenscar: Changes on Raven Hall Road
The pair of semi-detached villas near the centre of this photograph appear on the Estate Plan of 1918 when they were called Bay View and Glen Villa. A 'New Villa' was marked on the plan and is seen on the right but this was later altered and extended and another pair of houses built on the two vacant plots between the two pairs of semi-detached villas. On the left the road has been widened to provide parking space with magnificent views over Robin Hood's Bay.

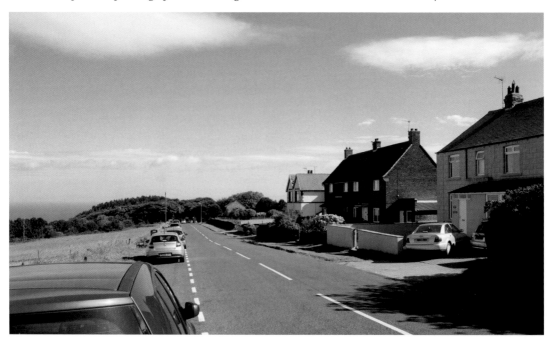

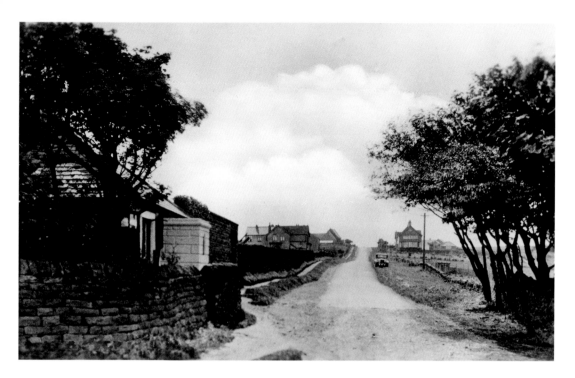

Ravenscar: Raven Hall Road from the Raven Hall Driveway

The view from the entrance to Raven Hall Hotel looking back up Raven Hall Road. In the distance on the right is Crag Hill Villa (page 79) and on the left The Lodge that stood at the entrance to Raven Hall prior to the building of Station Road, on the left, that leads to Station Square and Ravenscar station. Ravenscar was originally known as Peak but the name was changed on 1 October 1897 in conjunction with the development of the new seaside resort.

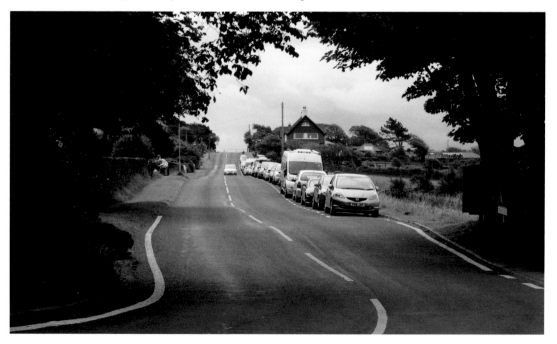

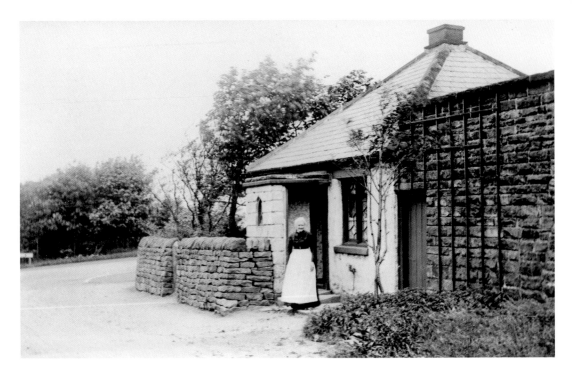

Ravenscar: The Lodge

The Lodge at the entrance to the driveway up to Raven Hall served as a gatehouse and more recently a café. It was an interesting single-storey building with a central chimney stack in a roof that sloped away on all four sides. Originally, in the 1880s, access to the railway station was directly across from Raven Hall Road and along the north-eastern boundary of the railway line. It was only when the Ravenscar Estate was developed that Station Road was built, see plan opposite.

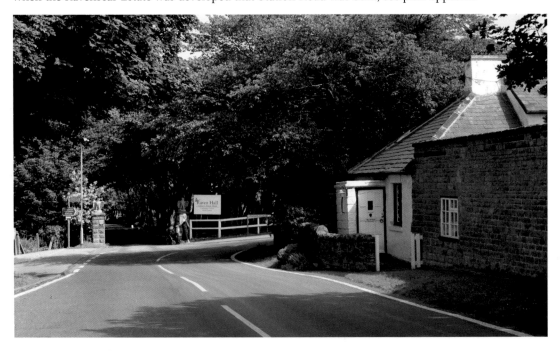

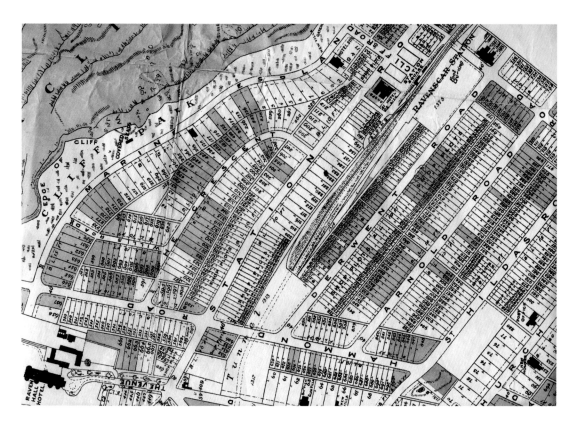

Raven Hall Hotel and the Ravenscar Estate

This illustration is a detail taken from an Estate Plan of 1918 and shows the area between Raven Hall Hotel (bottom left) and Ravenscar station (top right). All the streets and roads had been laid out, with drains, and the many plots of land were for sale in auctions that were held regularly in the Assembly Room behind the hotel. On the aerial photograph tennis courts can be seen in front of the building, and an open air swimming pool that was constructed in 1934.

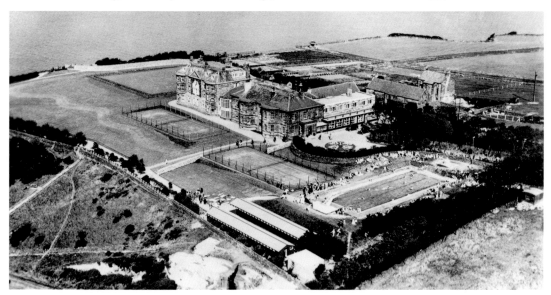

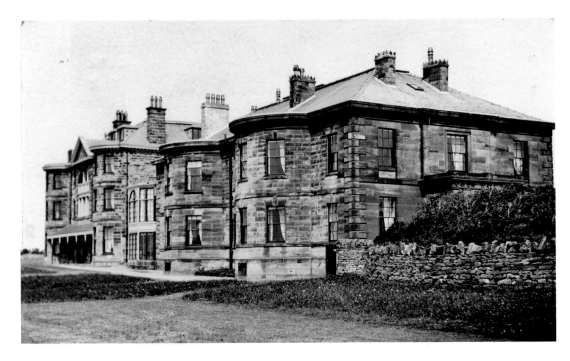

Raven Hall Hotel: a Historical Sight

The first mention of a house here, Peak House, was in 1542. In 1774 Captain William Child demolished Peak House and built a mansion on the site. Peak Hall or Raven Hall (both names were used) was mentioned in 1831 when the Revd Richard Child Willis began an extensive reconstruction of the hall – this is the building occupying the centre and right in the above photograph. Later extensions and additions were made when the building became a hotel in 1895; in 1898 it became the property of Hudson Hotels Ltd.

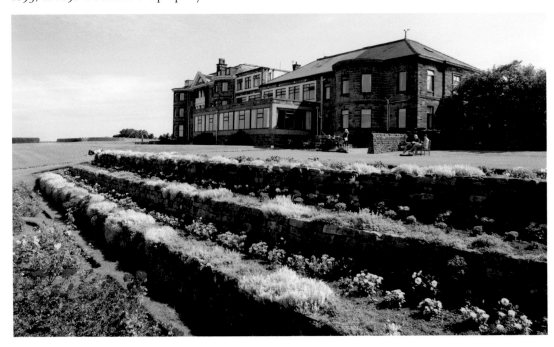

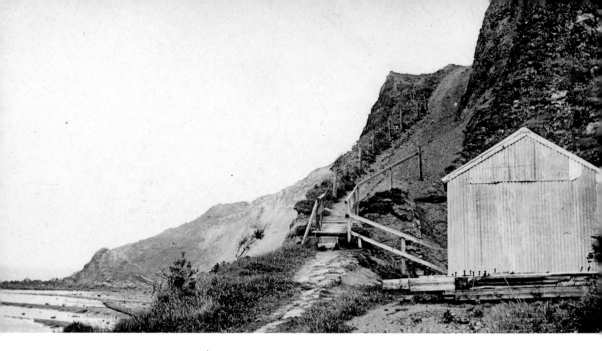

Raven Hall Hotel: all Change for Bathing
On the beach, below the old Alum Works, there was an old channel blasted out of the solid rock that made an ideal bathing place according to the Ravenscar Guide of 1898. This also stated that "a dressing shelter containing several cubicles has been provided at the head of the steps leading to the channel". A private footpath led from the hotel down to the bathing place but all this became redundant when a swimming pool was constructed next to the hotel in 1934 (see page 83).

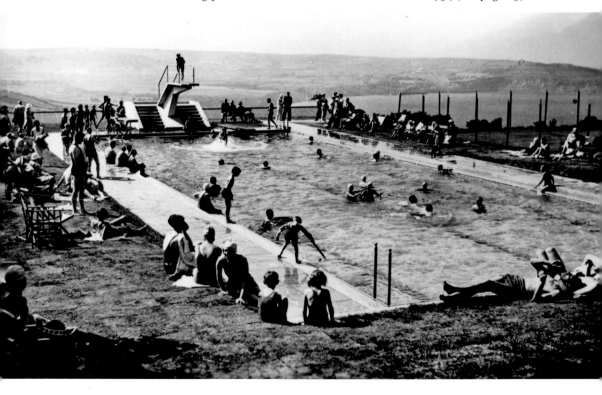

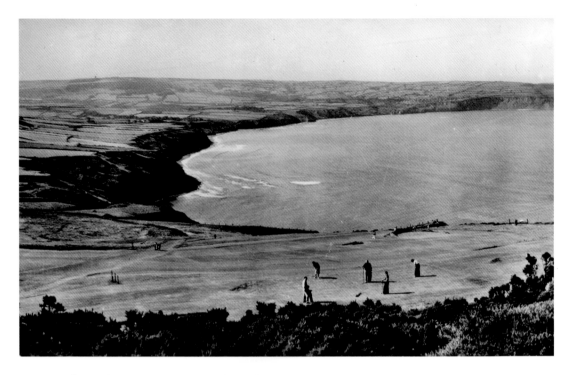

Raven Hall Hotel: Keeping an Eye on the Ball

The nine-hole golf course was opened by the Earl of Cranbrook in 1898. It was described as being in a delightful and most picturesque situation, overlooking Robin Hood's Bay, but the links themselves could not be described as good. Like the course at Robin Hood's Bay (opened in 1895 on Bay Ness) it was a "pretty sporting course abounding in natural hazards"! The stone dogs on the terrace are thought to be a present to a former owner of Raven Hall.

Ravenscar: the Coronation Stranded

This boat, bound from Bremen to Sunderland, was caught in a strong south-easterly gale and, only carrying ballast, became impossible to steer and in a blinding snowstorm ran broadside onto the rocks at Ravenscar in January 1913. Over 450 charges of gelignite were used to try and blast an escape channel and 100 tons of cement to seal the hull. Four tugs attempted to pull her clear but without success. In September, after being declared a total insurance loss she was refloated but burnt out in dry dock whilst under repair at Hartlepool a month later!

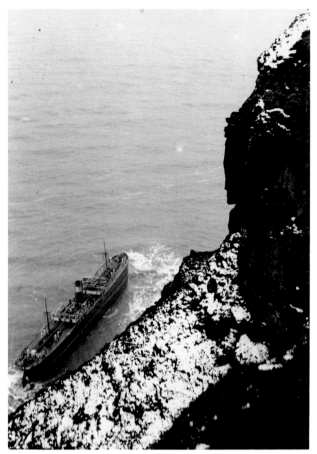

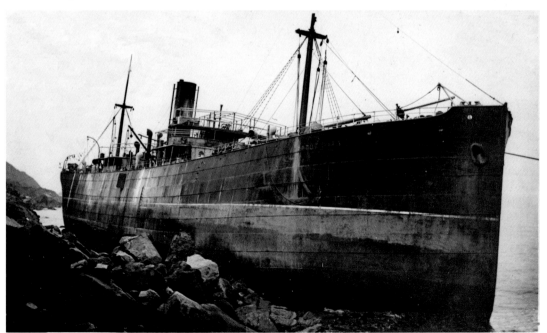

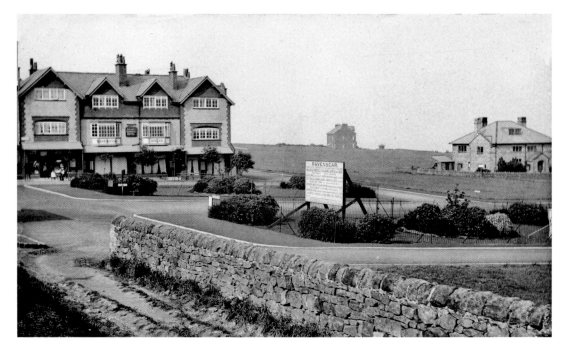

Station Square, Ravenscar
The view from the platform at Ravenscar station looking over Station Square. The large notice board opposite the station entrance advertised the new Ravenscar Estate – Highest cliffs in Yorkshire 600ft. Fine bracing air from sea and moor. Valuable freehold building sites for sale. Pure water. Good drainage. Golf Links (day's play 1/6d). Moorland walks. Cliff terraces and hanging gardens and Raven Hall Hotel. For prices of houses, building sites, plans etc apply to...Ravenscar Estate Company.

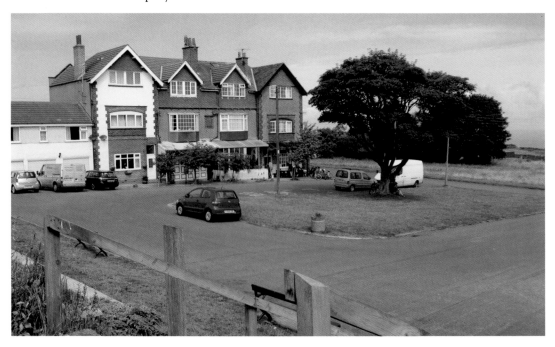

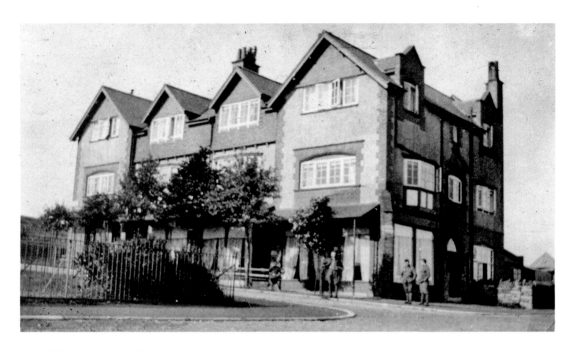

Skulduggery in Station Square

Ravenscar House in Station Square provided luncheons, dinners and board residence close to the station. Now, as the Ravenscar Tea Rooms, the café is very popular with walkers and hikers, particularly those using the trail-way along the old Scarborough–Whitby railway track. Ravenscar House was used as a billet for troops during the First World War and the old photograph shows men in military uniform in 1915.

Inset: This hippopotamus skull, photographed at Snainton station, later stood outside Ravenscar House but one foggy evening it disappeared – never to be seen again!

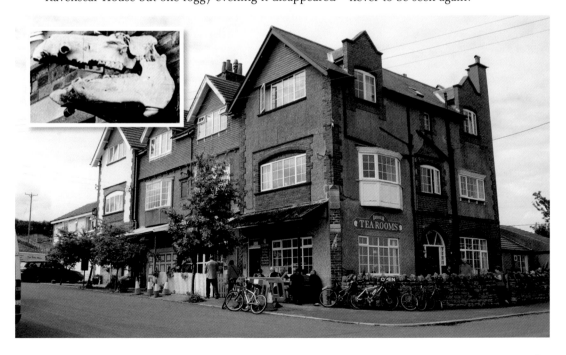

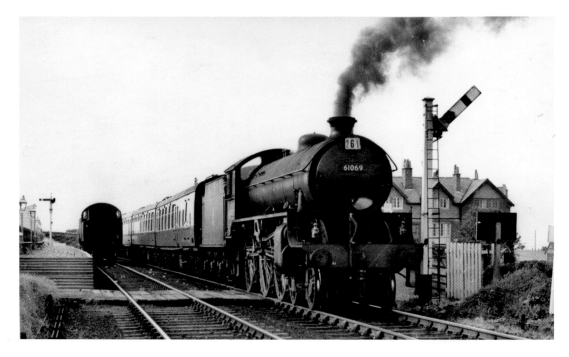

Ravenscar Station: Taking the Strain

The station appeared quite busy when excursion trains came down from Whitby. If there were more than five coaches they had to have the assistance of a pilot engine to climb the steep gradient up to Ravenscar. The trains stopped here so that the pilot engine, on the left, could be detached in order to run back light engine ready for the next excursion train. Now the trains have long since passed, the track and buildings have gone and trees and bushes take over the station site.

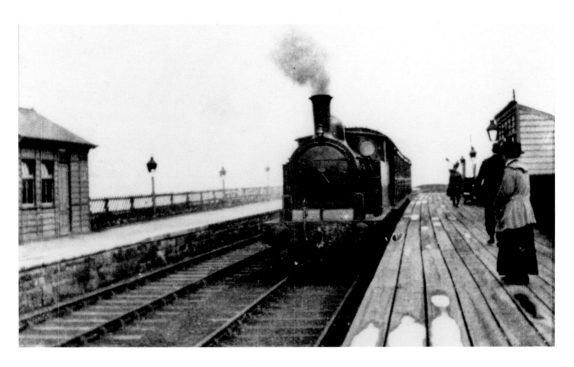

Ravenscar Station: Trains to the North

These two views were taken from the Whitby platform about forty-five years apart. The top one was taken in about 1915 when the platform lamps were mostly blacked out so that they were not visible from the sea during the First World War. The lower view was taken in about 1960 and shows the change of motive power from steam to diesel. Originally the station was called Peak which led to the confusion of passengers wanting the Peak District!

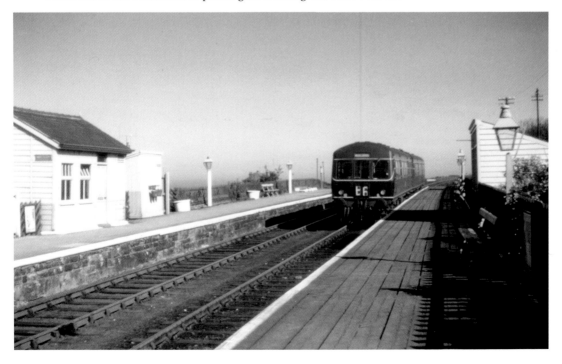

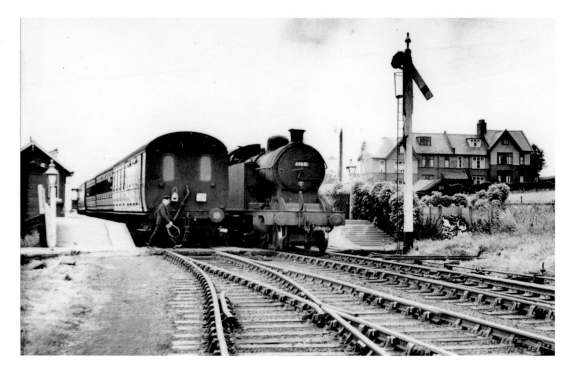

Ravenscar Station: a Line for All Seasons

Ravenscar is notorious for its inclement weather. At over 600ft above sea level it suffers from low cloud, sea frets and very strong winds – strong enough to blow the horns off a bullock according to one stationmaster here! The views are taken from the north end of the station, the top one on 23 July 1957. The lower photograph was taken in the bad winter of 1947 when a gang of men from York cleared the blocked line between Staintondale and Ravenscar.

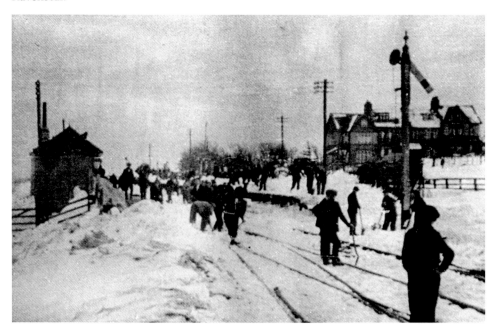

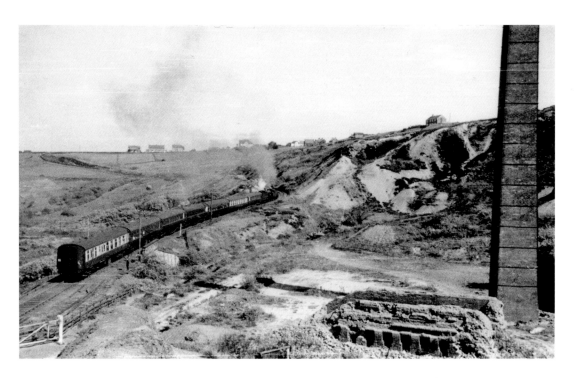

Ravenscar: from the Brickworks

In the foreground Whitakers Brickworks opened in 1900 on the site of the old Alum Quarry that was in operation from about 1650 to 1860. A great demand for bricks was expected because of the development of the Ravenscar Estate but very few of the plots were sold and the demand did not materialise. However the company did win the contract to supply the bricks for the Northstead Estate at Scarborough in the 1920s and this was facilitated by sidings that connected to the railway through the gate on the left.

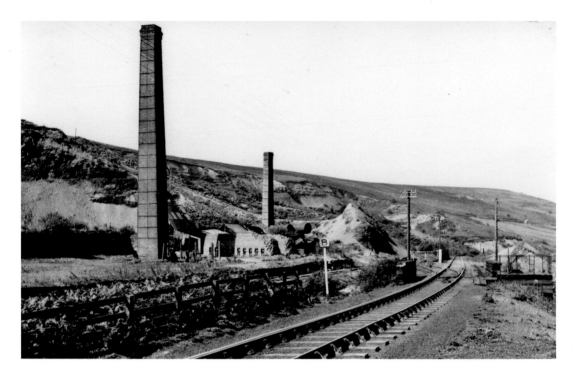

Ravenscar: a Very Industrious Past

In addition to the Alum Works and the brickworks there was also a ganister quarry on the moors near here. It was served by a narrow-gauge horse-drawn railway that ran to the top of the incline seen behind the two chimneys. The incline section was operated by a cable and drum system where two empty wagons were hauled up by two full ones descending. The stone had very high silica content and was used for lining blast furnaces. It was transferred to main line wagons on the old brickworks siding.

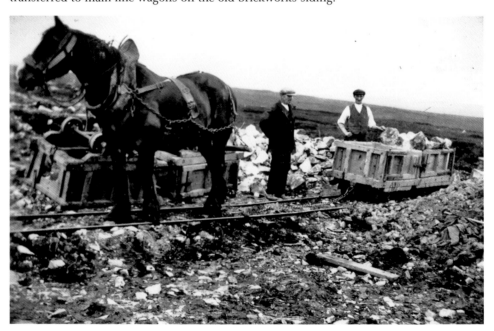

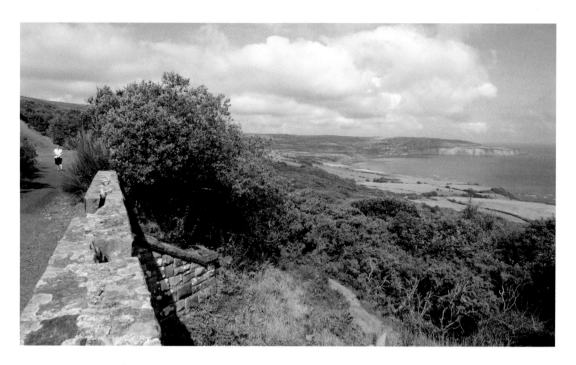

Ravenscar: Glories of Scene and Steam

The view from near the brickworks across to Robin Hood's Bay is magnificent and was the most scenic part of the Scarborough & Whitby Railway. Many excursion trains travelled this route giving holidaymakers an opportunity to enjoy the superb views as the trains slowly climbed their way to the summit at Ravenscar. The gradient was a steep 1 in 39 for about 2½ miles and the engines of the heavy excursion trains were working hard as they approached the tunnel just north of the station.

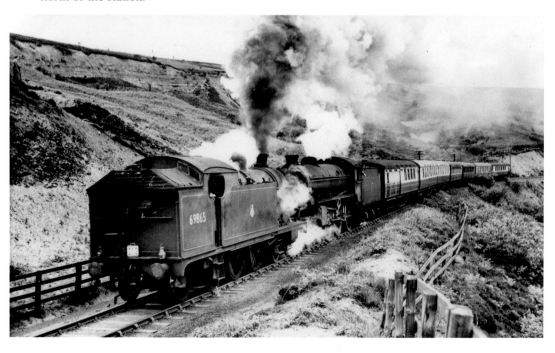

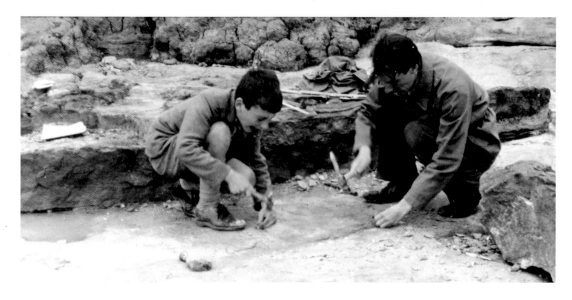

Footprints in the Sands of Time
Two fossil hunters, including a very young author, chisel out slabs of rocks containing the footprints of dinosaurs. In the middle Jurassic period these rocks were the soft sands on the banks of an estuary where the dinosaurs roamed. 150 million years later their footprints can still be found (see page 12).

Non Sibi Sed Omnibus

Bibliography

The following sources have been used in the preparation of this book: *The History of Ravenscar & Staintondale* by Frank Rimington, Scarborough Archaeological Society 1988; *The Raven Hall Hotel Ravenscar*, Hudson Hotels Ltd. 1898; *Bulmer's North Yorkshire – Thirsk and Malton and Whitby Division*, T. Bulmer & Co. 1890; *Historical Sketches of Scalby, Burniston and Cloughton...*, John Cole 1829; *Official Guide to the Scarborough & Whitby Railway*, Alex Wilson (secretary) 1897; *Shipwrecks of the Yorkshire Coast*, Arthur Godfrey and Peter Lassey, Dalesman 1982.